POSTCARD **HISTORY** SERIES

Spartanburg
South Carolina

POSTCARD HISTORY SERIES

Spartanburg
South Carolina

Jeffrey R. Willis
Andrew Helmus Distinguished Professor of History
Converse College

ARCADIA
PUBLISHING

Copyright © 1999 by Jeffrey R. Willis
ISBN 978-0-7385-0294-6

Published by Arcadia Publishing
Charleston, South Carolina

Printed in the United States of America

Library of Congress Catalog Card Number: 2005934210

For all general information contact Arcadia Publishing at:
Telephone 843-853-2070
Fax 843-853-0044
E-mail sales@arcadiapublishing.com
For customer service and orders:
Toll-Free 1-888-313-2665

Visit us on the Internet at www.arcadiapublishing.com

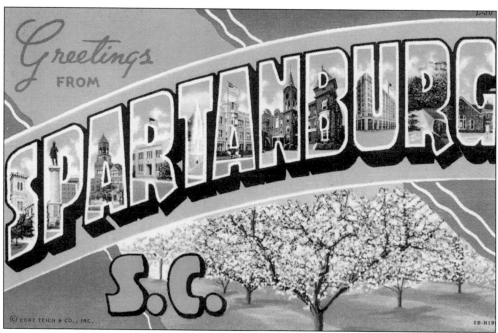

GREETINGS FROM SPARTANBURG, SC. (Curt Teich & Co., Chicago, IL.) Cards such as this one were produced for most United States towns. The letters contain representative town scenes with a peach orchard below. In the 1920s, peaches began to replace cotton as the county's principal crop.

CONTENTS

ACKNOWLEDGMENTS

This publication of Spartanburg postcards would be less broad if it had depended upon the author's collection alone. Many persons with an interest in the community have shared their postcards. Credit has been given at the end of each caption for those cards from other collections. Tommy Acker has been indispensible and tireless in his search for collectors and cards. A special debt is owed to him. Appreciation is extended to others who have lent their cards: Graham Bramlett, Dexter Cleveland, Steve Cromer, Ernest P. Ferguson, Scott Godfrey, Bill Littlejohn, George Mullinax, Gayle and Danny Russell, and the Regional Museum of Spartanburg County.

Every effort has been made to gather accurate facts about each card and to give useful information within the publisher's necessary limitations. A debt is owed to those who were willing to share their knowledge of local history. Carolyn Creal, curator of the Spartanburg County Regional Museum, has been generous in this respect. Ranny Brown and John Edmunds have patiently answered endless questions. Lawrence Sloan assisted with information about the South Carolina School for the Deaf and Blind. The Reverend Benjamin D. Snoddy was generous with his time and with information about the historic Mt. Moriah Baptist Church. Philip Stone was helpful in discovering Wofford College's architectural heritage. Martin Meek shared his knowledge of Spartanburg's buildings. Martha Dickens and Winnie Walsh helped research the collection in the Kennedy Room of the Spartanburg County Library. Alia Lawson lent tapes made by the late Dr. Lionel D. Lawson of his reminiscences of Spartanburg. All of these have made this a better publication. None of them is responsible for the errors, which are those of the author alone.

In addition, information has been drawn from a number of printed sources: J.B.O. Landrum's *History of Spartanburg County*; Philip Racine's *Spartanburg County: A Pictorial History*; Vernon Foster's *Spartanburg: Facts, Reminiscences, Folklore*; *Spartan Mills: 100th Anniversary*, compiled by Brian Long; John C. Edwards's, "Doughboys and Spartans: The Story of Camp Wadsworth," in *South Carolina History Illustrated*; Ella Poats, *Spartanburg County School District Seven: The First Ninety-Eight Years*; and *Camp Croft: 50th Anniversary Celebration*.

Appreciation is expressed to the Trustees of Converse College for a summer research grant, which made the completion of this project possible. Mark Berry, at Arcadia Publishing, has provided valuable editorial and technical assistance.

JRW
Summer 1999

INTRODUCTION

At the turn of the twenty-first century, Spartanburg is beginning a Renaissance Project, which will see the construction of a new hotel and convention center, extensive improvements to the Municipal Auditorium, and the construction of new shopping areas and parks. In addition, a new main branch of the Spartanburg County Public Library was opened in 1997.

In many ways Spartanburg experienced its first Renaissance Project 100 years earlier in the 1880s and 1890s. The Spartan Inn was the town's first large hotel. The Kennedy Free Library and an Opera House were built on Morgan Square. A new courthouse was constructed on Magnolia Street, and the new Duncan Building and Palmetto Building provided space for shops and offices. This period of expansion and population growth continued on through the first quarter of the twentieth century. It was not unusual for a structure of a fairly monumental size to be put up, used for about 25 years, and then taken down and replaced.

This period of rapid progress coincided with an act of Congress in 1898 allowing the sending of private mailing cards through the United States Postal Service. The postcard appeared at the right time to record the changing face of Spartanburg. It is the half century, from about 1880 to 1930, that this volume hopes to chronicle. Since many of the results of Spartanburg's first Renaissance Project have now disappeared, the need for such a pictorial record seems all the greater.

In compiling this record, the temptation to include photographs has been resisted, with a couple of exceptions, in order to remain true to the original theme of the work: "a postcard history." Although this decision makes for a less comprehensive record, it is strongly believed that the ubiquitous little card provides an enjoyable means of preserving and recreating the history of a community. Philip Racine's pictorial history of Spartanburg has already utilized the photographs. There is no need to duplicate that excellent work.

The history of the postcard has been much retold in other postcard histories. That information will not be repeated here. The newcomer to the genre may be interested in one phase of the postcard's evolution. When the sending of private mailing cards was first allowed in the United States, there was no space for written messages. Only the name and address of the recipient were allowed on the reverse side from the picture. This led to messages being written across the pictures—to the annoyance of later collectors. In response to need and practice, the United States government allowed messages to be written to the left of the address space after March 1, 1907. Most cards subsequently printed have a line dividing the two spaces.

No presumption is going to be attempted in emulating the expertise of Howard Woody and Thomas L. Johnson in the descriptions of the size, hue, and origins of cards which they have so ably given in the first volumes of their series on South Carolina postcards. For the benefit of those who pick up this humble volume, the information of which the author is capable is cited. Otherwise it is hoped that the readers will enjoy this collection of Spartanburg cards and that the comments will be useful.

VIEWS OF SPARTANBURG, SC. (Black-and-white, *c.* 1905.) This card, with an undivided address side, has scenes of Wofford College's Science Hall, the Spartan Inn, Converse College and Founder's Monument, the Morgan Monument, Wofford's Fitting School, First Presbyterian Church, Wofford's Main Hall, and Morgan Square.

One

MORGAN SQUARE

During the colonial period, what would become Spartanburg County was truly "backcountry" and consisted mostly of Cherokee Indian lands. After an agreement between the British governor and the Cherokees opened the area to settlement, the first British settlers began to arrive in the 1750s and 1760s. Many of them were Scots Irish who came first to Pennsylvania and then traveled south down the Great Wagon Road. Some stopped off in western Virginia and western North Carolina, and others ventured on into the South Carolina backcountry. The first settlements were on what would become the "west side of town" in the area of Nazareth Presbyterian Church, which was established about 1770.

Prior to the American Revolution, there was no county or village of Spartanburg. Following the war, the South Carolina Legislature ruled that counties be created in all parts of the state where they did not yet exist. Spartanburgh County was created in 1785. The two essentials for organized society at the time were a county courthouse and a jail. Thus, a need for property was created. Thomas Williamson's plantation was located at what was just about the geographic center of the new county. A nearby spring was also a probable factor in the site selection. The recently appointed county justices were authorized to buy several acres from Williamson and to construct the necessary county buildings. Thus began what would later be named Morgan Square.

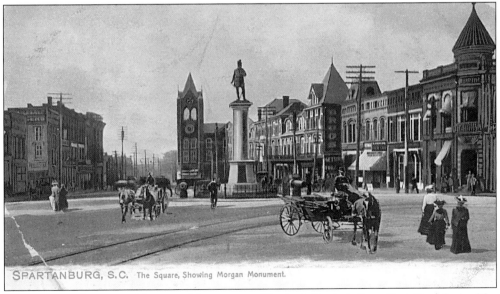

SPARTANBURG, S.C. The Square, Showing Morgan Monument.

THE SQUARE SHOWING MORGAN MONUMENT. (Raphael Tuck & Sons Post Card Series No. 2389, c. 1900.) The building with the clock tower is the Opera House, designed by Godfrey Norman and built in 1880. Spartanburg's city hall occupied the first floor. On the second floor there was an auditorium. The building was torn down about 1907 and the property sold to the Masons, who built the present Masonic Temple on it in 1928.

Near where Magnolia Street would later begin, the county justices had a wooden courthouse built sometime between 1787 and 1789 in the center of the property. At the east end of the square, a small jail was built from timber. A public well provided a water supply. This well would be filled in toward the end of the nineteenth century.

The Square was almost a century old when its namesake and most enduring feature, the Morgan Monument, was erected in 1881 to commemorate the centennial of the Battle of the Cowpens. New York sculptor J.Q.A. Ward created the 8-foot-tall likeness. The statue was cast in bronze by Burea Brothers and Heaton, a Philadelphia foundry. The $40,000 cost for statue and pedestal was raised by contributions from the 13 original states plus Tennessee. It was said that this was the first cooperative effort between North and South since the Civil War. The *Carolina Spartan* reported that all 14 governors attended the dedication on May 11, 1881. An oration was delivered by Senator Wade Hampton, who read a message from President James Garfield expressing his regret at not being able to attend. The newspaper account praised the statue with the following: "The face is a noble piece of work, the features are massive, regular and dignified, and the expression is as near perfect as possible. It is that of a brave man, suddenly alarmed, showing not the trace of fear, but a keen lookout, perfect self-possession, and a preparation for any emergency that may arise."

When erected in 1881, the monument faced east and was put on the site of the first courthouse. In 1960, as changes were being made in the Square, the statue was moved to the east end and turned around to face west.

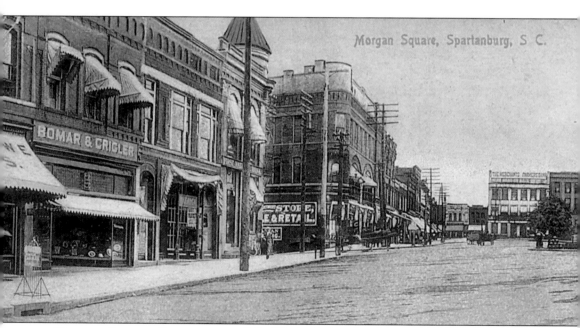

MORGAN SQUARE, SPARTANBURG, SC. (SL & Co.?, printed in Germany, *c.* 1905.) In this panoramic view of Morgan Square, looking east, the statue of General Daniel Morgan is shown at the intersection of Morgan Square and Magnolia Street (on the left). Later, about 1960, the statue was moved to the extreme east end of the square, where Church Street crosses over. Bomar & Crigler were clothiers. The north side of the square has been the site of stores and of hotels and

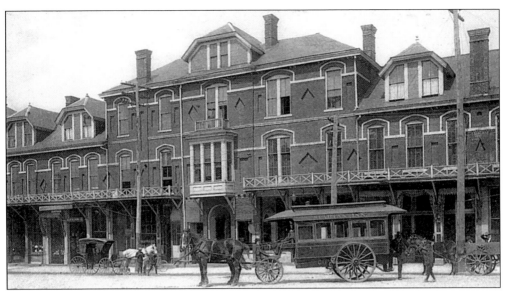

SPARTAN INN. (The Rotograph Co., New York.) The Merchant's Hotel was built in 1880. Several years later, new owners changed the name to the Spartan Inn. All 75 guest rooms were lighted with gas. The horse-drawn van was used to collect guests at the train station.

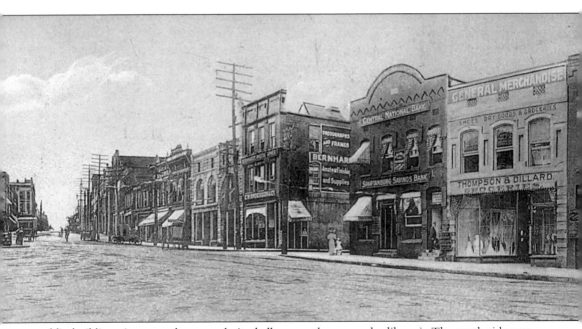

public buildings (an opera house and city hall, a courthouse, and a library). The south side was primarily commercial. The view shown above in this double card is useful for showing these less-photographed commercial buildings, many of which survive today. (Card courtesy of the Regional Museum of Spartanburg County.)

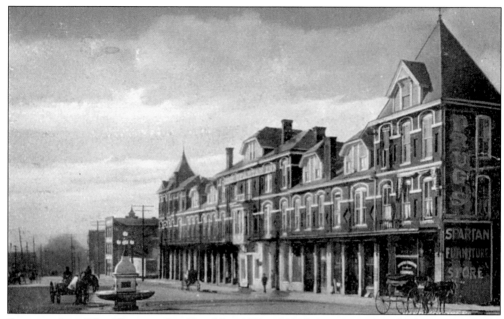

Spartan Inn. (The Albertype Co., Brooklyn, NY, *c.* 1907.) Commercial establishments occupied much of the ground floor of the hotel. R.O. Pickens's roofing business was located there. In the parlor, Dr. I. Crimm, "the famous eye specialist," had his office. When fire destroyed the Spartan Inn in 1910, the Cleveland Hotel was built on the site. Today it is a vacant lot.

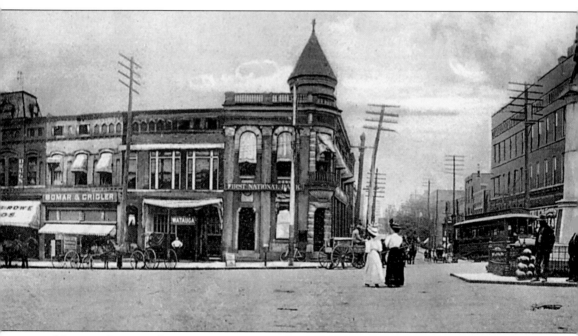

Morgan Square, Spartanburg, SC. (A.M. Simon, New York, made in Germany, black-and-white, *c.* 1905.) In this panoramic view of the north side of Morgan Square, the trolley car is emerging from Magnolia Street. The three store buildings on the extreme left are the only structures, shown in this picture, remaining today. The Second Empire roof of the building at

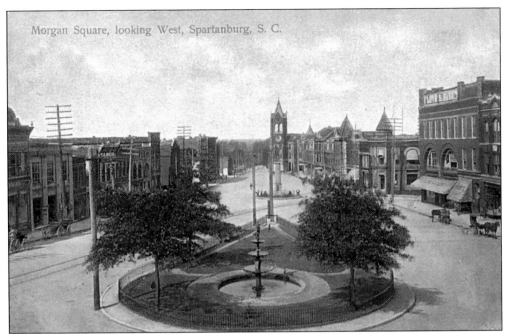

Morgan Square, looking West, Spartanburg, S. C.

MORGAN SQUARE, LOOKING WEST. (International Post Card Co., New York, printed in Germany, *c.* 1907.) This scene is probably from the early 1890s. In 1872, the fountain replaced the old public well. Rows of chinaberry trees were planted around the grassy area.

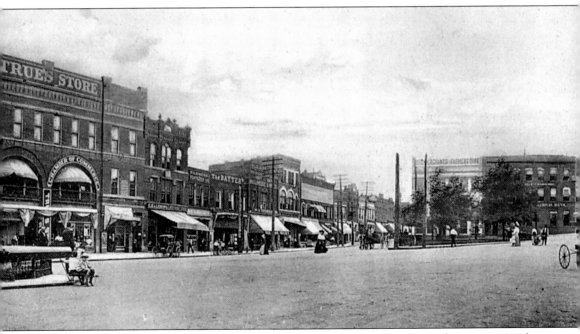

the left end has been recently restored. On the west corner of Magnolia Street is the First National Bank of Spartanburg with its cone-crowned tower. On the east corner is the Duncan Building, which housed True's Store and the Chamber of Commerce. (Card courtesy of the Regional Museum of Spartanburg County.)

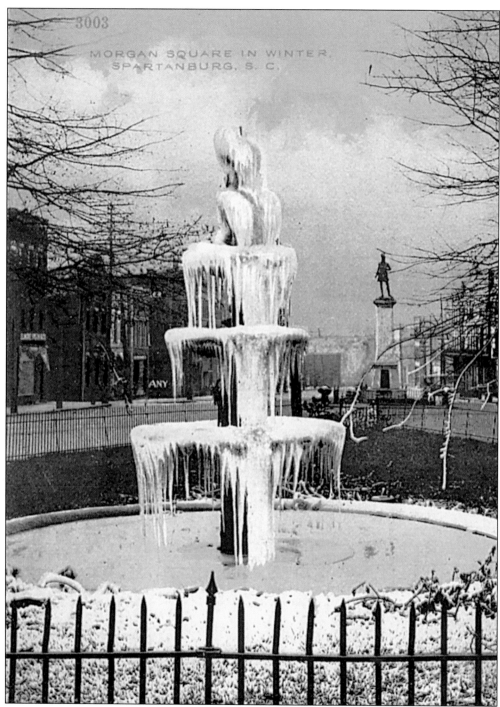

MORGAN SQUARE IN WINTER. (S.H. Kress & Co., *c.* 1907.) This unusual winter scene is from a postcard postmarked 1912. When the City decided to remove the fountain from the Square, a donor purchased it and gave it to Converse College. First located on the front campus, the fountain was later moved to the Gwathmey Rose Garden on Converse's back campus. It has recently undergone extensive restoration.

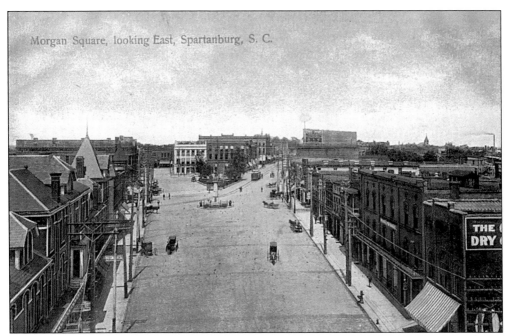

MORGAN SQUARE, LOOKING EAST. (International Post Card Co., New York, No. 685, printed in Germany.) This almost ariel-like view dates from about 1905. It was possibly taken from the tower of the Opera House and shows that Morgan Square never was a "square," but a misshaped rectangle at best. The Spartan Inn is on the extreme left.

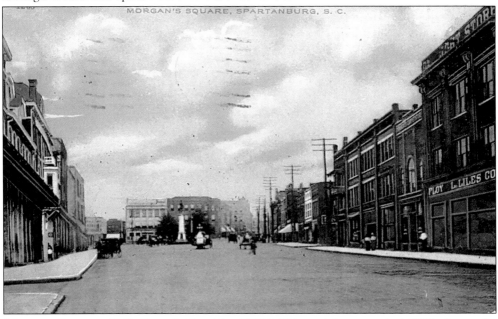

MORGAN SQUARE. (S.H. Kress & Co., No. 1268.) This card is postmarked 1910. Across the square from the Spartan Inn was the Floyd L. Liles Company at 62–64 Morgan Square. The store dealt primarily in clothes and carried boys and children's school suits. Mail orders were shipped to any destination. Liles was a leading merchant and owned a home on the corner of East Main Street and Mills Avenue.

15

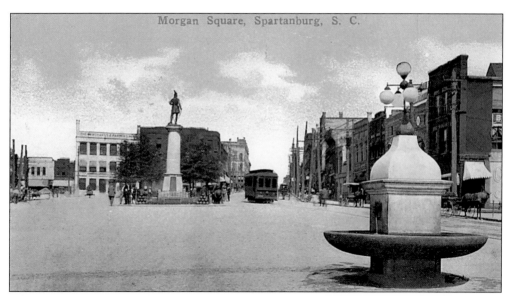

CLEVELAND FOUNTAIN. The fountain was dedicated to the memory of Jesse Cleveland (1785–1851), who came to Spartanburg in 1810 and became a leading merchant. His home was once located nearby on Morgan Square. The fountain was later relocated to Cleveland Park. Today it is located on a triangular plot where the Asheville Highway branches off from North Church Street.

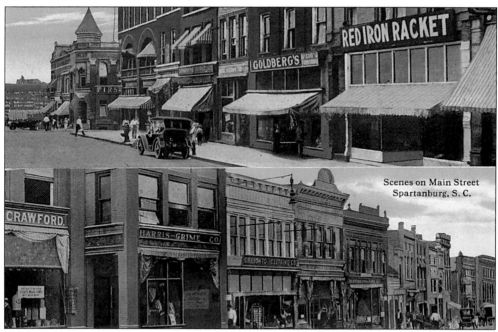

SCENES ON MAIN STREET. (C.T. Photochrom.) The top scene shows the north side of Morgan Square. The First National Bank is at the left. The Red Iron Racket Store conducted price wars with J.D. Collin's Beehive Store. The bottom half shows the south side of the Square sloping down toward Wall Street. Montgomery and Crawford's Hardware Store is on the left. Harris and Grime carried dry goods for wholesale and retail sale. (Card courtesy of Gayle and Danny Russell.)

MORGAN MONUMENT. (Rotograph Co., New York, printed in Germany.) This card was published prior to 1907 and shows the First National Bank of Spartanburg, with its cone-shaped tower, on the northwest corner of Morgan Square and Magnolia Street. It was established in 1871 with a capital stock of $100,000 and was the first bank in Spartanburg County. George Cofield was an early president. Also associated with the bank, and both later presidents, were Augustus M. Creitzberg and Wilbur E. Burnett. An affiliate of the bank was the Fidelity Loan and Trust Company, organized in 1887.

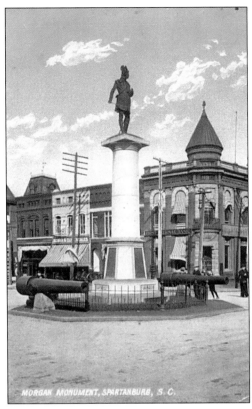

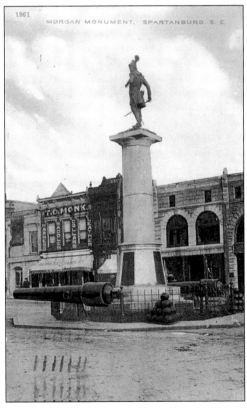

MORGAN MONUMENT. (S.H. Kress & Co., c. 1907.) Sometime after the erection of the Morgan statue, cannon and stacks of cannonballs were put around the base; during World War II, they were removed and melted down. The buildings are on the south side of the Square. Thomas Overton Monk was a leather merchant.

17

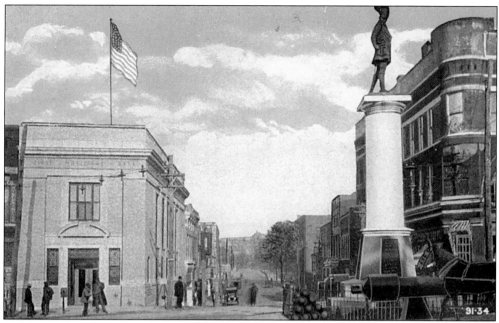

MORGAN MONUMENT AND MAGNOLIA STREET. (Carolina Card Co., Asheville, NC.) As Spartanburg grew rapidly, the First National Bank outgrew its first building and replaced it, in 1915, with the building shown on the left in this view. The new building soon became too small and was later widened. The enlarged structure survives today on its corner.

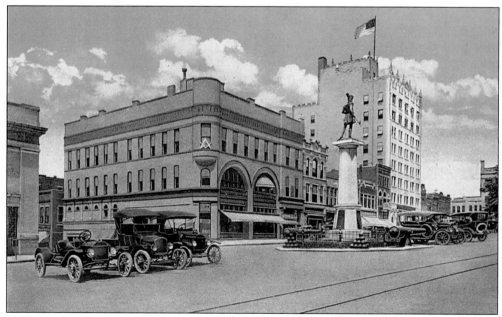

MORGAN MONUMENT. (Southern Post Card Co., Asheville, NC.) The Duncan Building is shown on the northeast corner of Morgan Square and Magnolia Street in this scene, which dates from about 1920. A syndicate, headed by T.C. Duncan, demolished Spartanburg's third, Greek-Revival courthouse and constructed this building for stores and offices. The site is now a vacant lot.

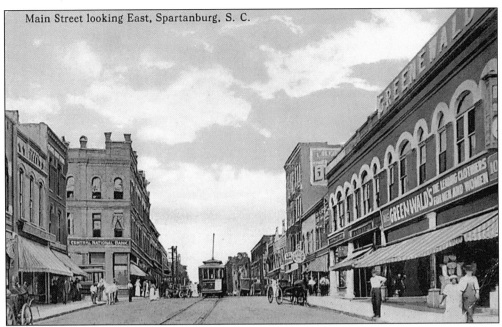

Main Street looking East, Spartanburg, S. C.

MAIN STREET, LOOKING EAST. (C.T. Photochrom.) This picture was taken just below the crossing of Church Street and Morgan Square. Greenwald's, during its early years, carried clothes for both men and women. The east end of the building, above Greenwald's, was removed during the late 1950s to widen Church Street. (Card courtesy of Gayle and Danny Russell.)

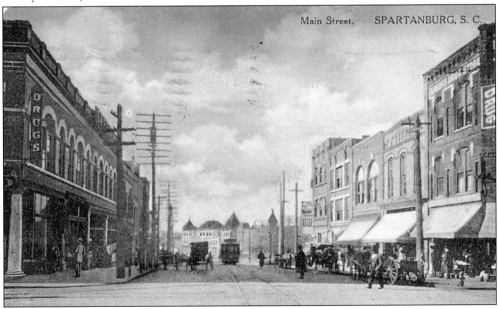

Main Street. SPARTANBURG, S. C.

MAIN STREET. This picture is taken from almost the same point as the one above, but looks west from Church Street. Greenwald's, now on the left, first opened in 1886 and was located in the Duncan Building before it moved, in 1910, to the building in this scene. The Spartan Inn is at the bottom of the Square in the center of the card. (Card courtesy of Gayle and Danny Russell.)

19

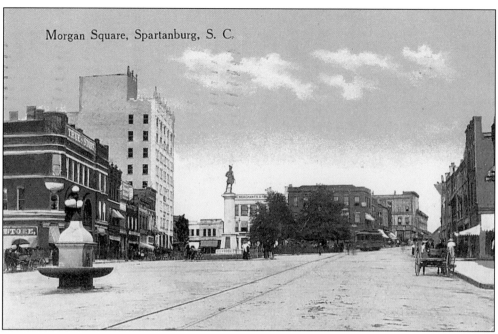

Morgan Square, Spartanburg, S. C.

TRUE'S STORE, MORGAN SQUARE. In 1905, True's Department Store opened in the Duncan Building, shown on the left in this 1917 postmarked card. True's had the first elevator in Spartanburg.

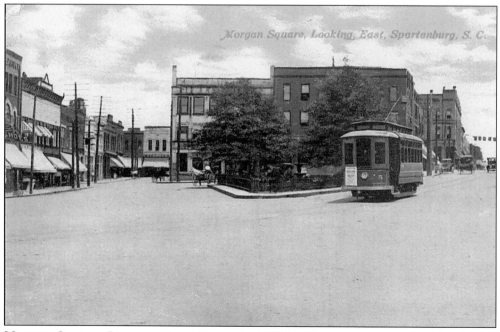

Morgan Square, Looking East, Spartanburg, S. C.

MORGAN SQUARE, LOOKING EAST. (Postmarked 1913.) The northeastern end of the Square, going up to Church Street, was called Kennedy Place after Lionel C. Kennedy, whose physician's office was on the site occupied, in this view, by the first building of the Kennedy Free Library—the building with the crest and without an awning.

CHAPMAN BUILDING. (Carolina Card Co., Asheville, NC.) Spartanburg's first skyscraper was built in 1912 by a New York businessman and designed in the style of the Chicago school of architecture by Julius Harder of New York. In 1922, it was sold to Isaac Andrews and renamed the Andrews Building. Prepared for demolition in 1977, it tragically came down a day early, killing several workmen trapped inside.

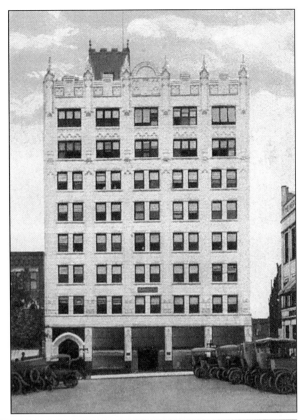

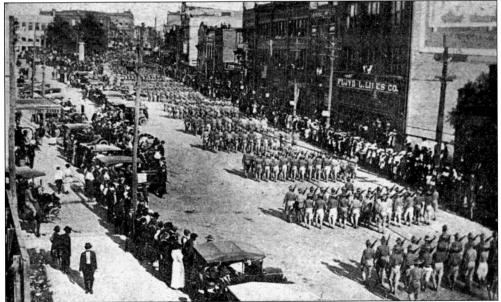

LIBERTY LOAN PARADE, OCTOBER 18, 1917. (Photoprint.) After the United States entered World War I, liberty parades were held all over the country to promote the sale of war bonds. The first troops had arrived at Cape Wadsworth, outside of Spartanburg, just a month before this picture was taken. (Card courtesy of Tommy Acker.)

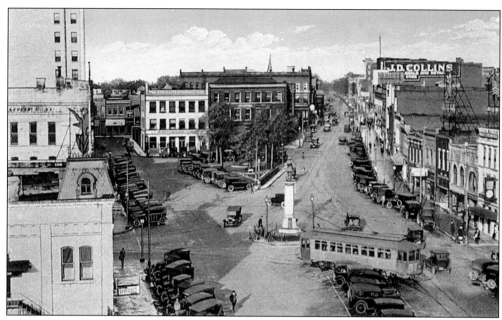

The Square, Spartanburg, SC. (Southern Post Card Co., Asheville, NC.) This scene dates from the late 1920s and is in contrast to the views on the preceding pages. The increase in vehicular traffic almost equals today's conditions. Trolley cars were still in use, but were being replaced by gasoline buses.

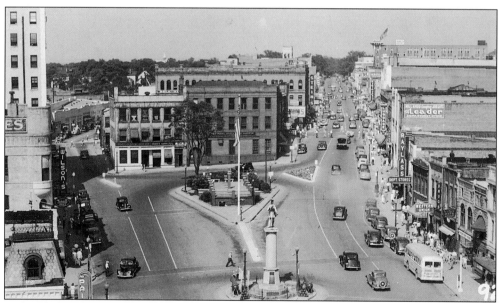

Main Street, Looking East. (Photoprint, *c.* 1940.) In this scene a bandstand has replaced the once tree-lined plot and decorative fountain at the top of the Square. Above the bandstand are buildings located on an "island" at the east end of the Square. The building, facing East Main, was the home of the American National Bank. These buildings were demolished in the late 1950s when Church Street was widened from two lanes to four.

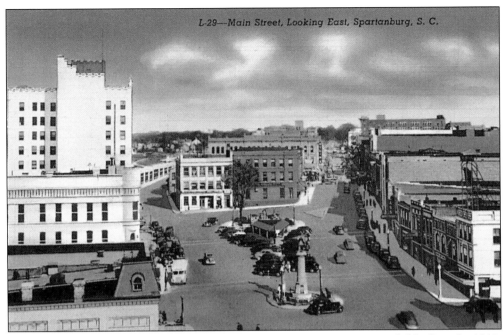

L-29—Main Street, Looking East, Spartanburg, S. C.

MAIN STREET, LOOKING EAST. (Curt Teich, Chicago, IL.) This scene is probably from the 1940s and shows a triangular covered area at the end of the bandstand. In the horizon on the far right is the Franklin Hotel.

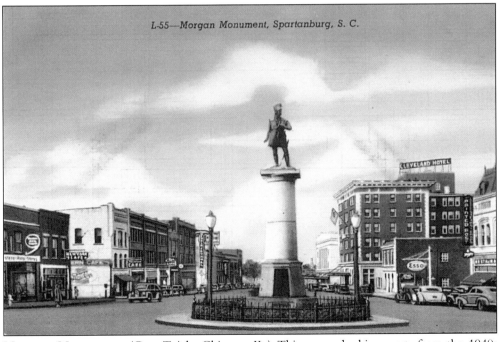

L-55—Morgan Monument, Spartanburg, S. C.

MORGAN MONUMENT. (Curt Teich, Chicago, IL.) This scene, looking west, from the 1940s shows the changes to the northwest side of Morgan Square. The Cleveland Hotel has replaced the Spartan Inn, and the Masonic Temple, at the very west end, has replaced the Opera House. Note the Esso station on the right and the Western Auto Store on the left.

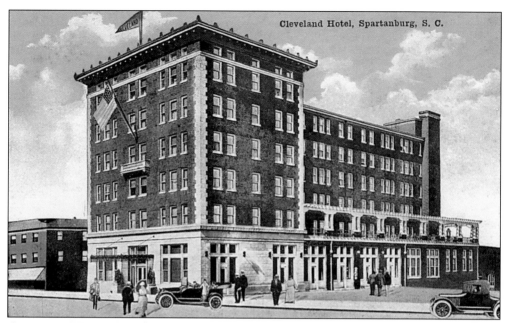

CLEVELAND HOTEL. (Carolina Card Co., Asheville, NC.) This card is postmarked 1922. John B. Cleveland, who had been one of the owners of the Spartan Inn, was a partner in the construction of the Cleveland Hotel, which opened in 1917. Built on the west end of the site where the Spartan Inn had stood, the Cleveland Hotel was demolished in 1992.

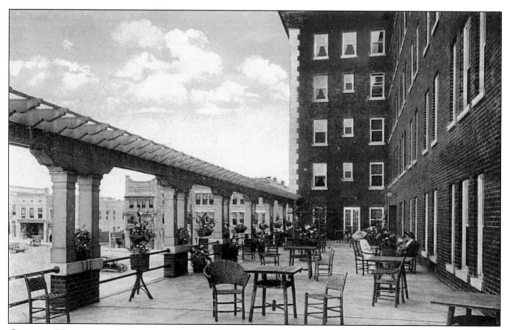

ON THE TERRACE, CLEVELAND HOTEL. (Asheville Post Card Co. Asheville, NC.) The hotel's terrace was a popular place to sit and have a light meal. The south side of Morgan Square is seen in the background.

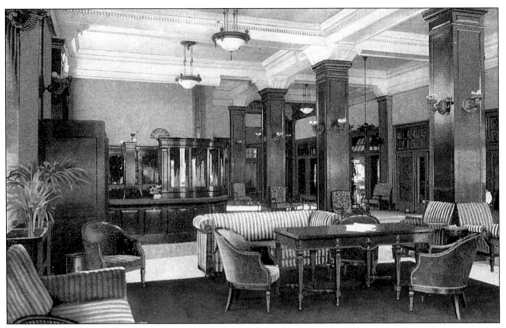

THE LOBBY, CLEVELAND HOTEL. (Carolina Card Co., Asheville, NC.) In this card, postmarked 1922, the hotel lobby is shown in what was probably its original appearance.

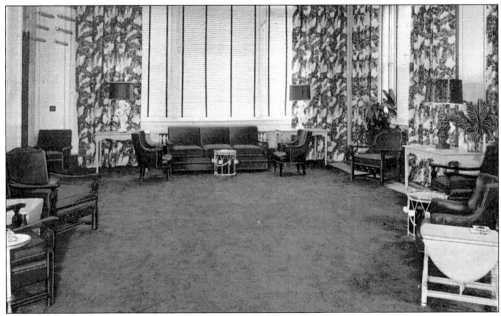

VIEW OF THE LOBBY, CLEVELAND HOTEL. (Asheville Post Card Co., Asheville, NC.) This card is postmarked 1932 and shows the hotel lobby updated to 1930s tastes. On the reverse side, J. Mason Alexander is listed as the hotel director. He also managed the Poinsett Hotel in Greenville, South Carolina.

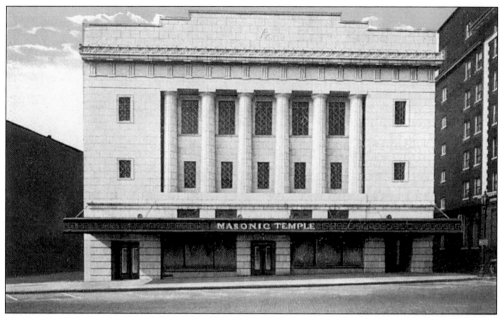

MASONIC TEMPLE. (E.C. Kroff Co., Milwaukee.) On the site of the former Opera House, the Masons built their temple in 1928, just west of the new Cleveland Hotel. The rusticated ground-floor facade, pilasters, and classical entablature represent the neo-classical features popular in the architecture of the time. This building still stands on Morgan Square. (Card courtesy of Tommy Acker.)

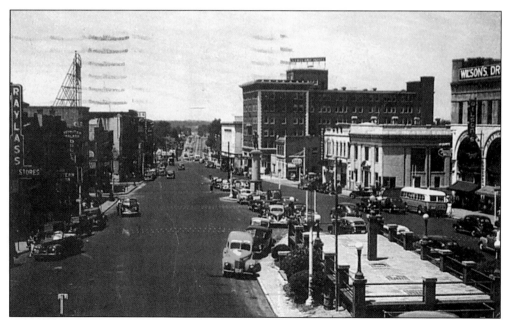

MORGAN SQUARE, SHOWING HOTEL CLEVELAND. (Southeastern Paper Corp, Spartanburg, SC.) This view of the bandstand probably dates from the late 1940s. The white facade of the Masonic Temple appears below the Cleveland Hotel. Gasoline buses, like the one in front of the Duncan Building, replaced the trolley cars by the 1930s.

Two

MAGNOLIA AND CHURCH STREET

Extending north from the middle of Morgan Square, Magnolia Street began to develop as the town spilled out of its original center. As Morgan Square became more commercial, Magnolia Street became the location of the courthouse, schools, a library, hotels, and residences. Part of the street's significance resulted from its being the connection between the train station and Morgan Square.

A few cards, which do not relate to Magnolia Street, are included in this chapter because they show railroad scenes. It seemed sensible to group all of these together with the train station.

Church Street crosses the top of Morgan Square and extends both north and south. It forms the division between the eastern and western areas of Spartanburg. Numerous churches are located on both ends of the street. In addition to residences, Church Street was the location of Wofford College, schools, and a hospital. This chapter also includes several cards showing scenes just off Church Street and of the Hampton Heights neighborhood.

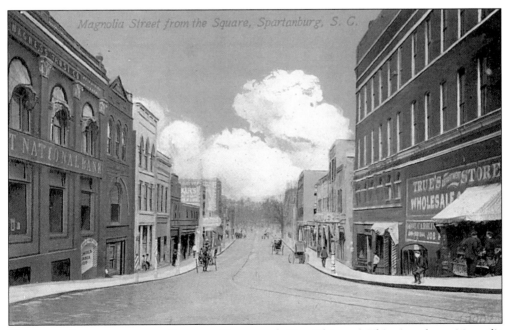

MAGNOLIA STREET FROM THE SQUARE. (Acmegraph Co., Chicago.) This view down Magnolia Street dates from about 1905. True's Department Store and the Duncan Building are on the right. The old First National Bank building is on the left. (Card courtesy of Tommy Acker.)

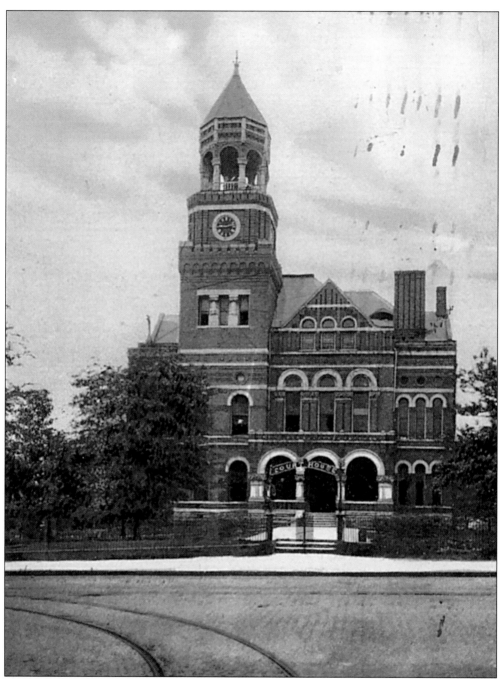

SPARTANBURG COUNTY COURT HOUSE. (S.H. Kress & Co, No. 2051.) When the Duncan Building replaced the courthouse on Morgan Square, a fourth courthouse was built on Magnolia Street. The cornerstone was laid on May 22, 1891. Godfrey Norman, who was also the architect of the Opera House and the Merchant's Hotel, designed the courthouse in the popular Romanesque style of the late nineteenth century. Norman designed many of Spartanburg's new buildings in the 1880s and 1890s. After that, he moved to Atlanta where the prospect of new commissions was greater.

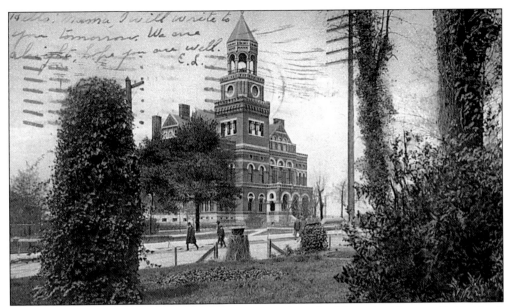

COURT HOUSE, SPARTANBURG, SC. (The Rotograph Co.) This card with an undivided back dates from about 1904. The clock and bell in the tower were moved from the Opera House on Morgan Square. When this courthouse was torn down in the late 1950s, the clock and bell were put into storage and later reinstalled in the new tower on Morgan Square.

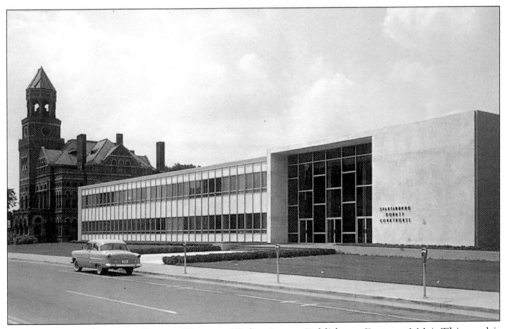

SPARTANBURG COUNTY COURT HOUSE. (Colorpicture Publishers, Boston, MA.) This card is one of many that was distributed by the City News Agency. Construction of Spartanburg's fifth courthouse began in 1957. The architect was Harold Woodward. Although the old building is still standing in this scene from about 1958, it was soon demolished.

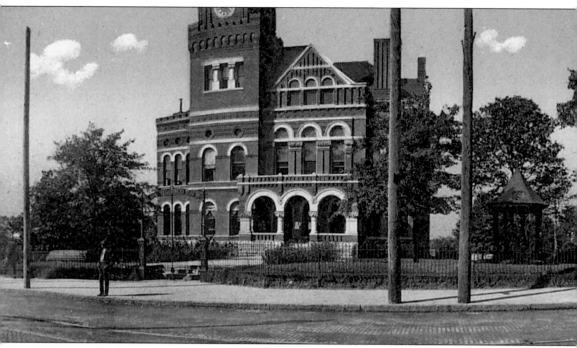

COURT HOUSE, GRADED SCHOOL, & MAGNOLIA STREET. (Irwin's Drug Store, Spartanburg, SC, printed in Germany.) The panoramic view given in this double card gives a false impression of a curved street. The scene shows the ample wooded lawn, with a gazebo, which enhanced the site of the courthouse. The Graded School will be discussed in a later chapter.

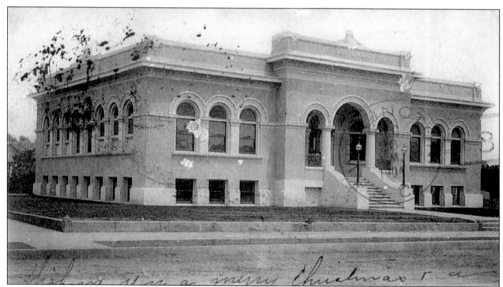

KENNEDY FREE LIBRARY. (Illinois Post Card Co., New York.) The Kennedy Library eventually outgrew its original premises on Morgan Square. When Andrew Carnegie donated $15,000, this building was constructed on Magnolia Street just north of the courthouse and the Graded School. Formally opened on January 15, 1906, the new library had electric lights and steam heat.

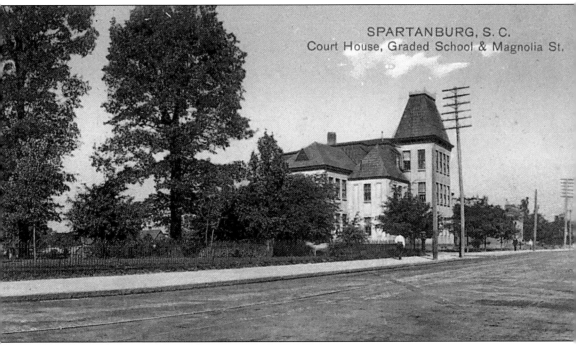

To the north of the school was the second location of the Kennedy Free Library. Both the school and the library would be demolished to build the current Spartanburg County Court House. The brick paving on Magnolia Street is clearly visible. (Card courtesy of the Regional Museum of Spartanburg County.)

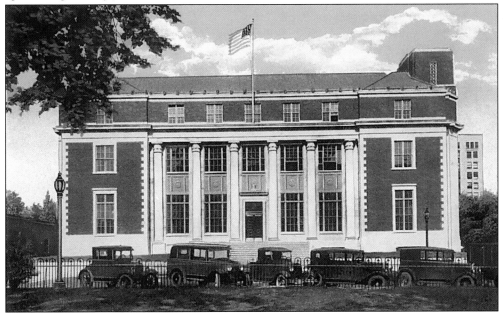

U.S. POST OFFICE AND GOVERNMENT BUILDING. (Asheville Post Card Co., Asheville, NC.) This large building with its classical revival entrance was constructed, at a cost of $420,000, in 1930 across Magnolia Street from the courthouse. Today it is the Donald S. Russell Federal Office Building and Court House.

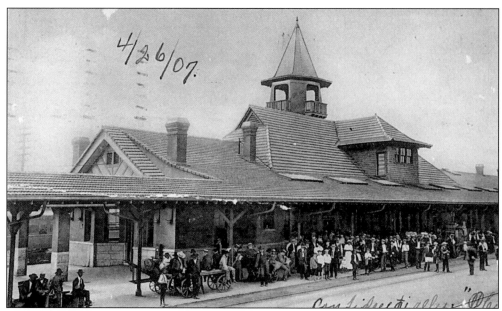

UNION DEPOT. (Rowe & Rowe, Spartanburg, SC, printed in Germany.) The railroad first came to Spartanburg in 1859 and was a major factor in the economic development of the town. The Union Depot was built in 1904 and consisted of three buildings. Two of the original buildings were torn down in 1973 and the remaining one was damaged by fire in the 1990s. It is currently under restoration.

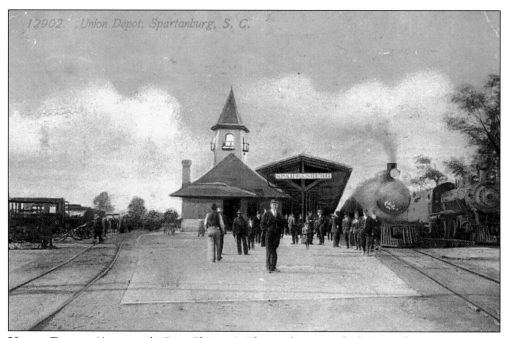

UNION DEPOT. (Acmegraph Co., Chicago.) The card, postmarked 1914, shows two engines ready to pull out of the depot. By that time 18 passenger trains stopped at the station daily. (Card courtesy of Bill Littlejohn.)

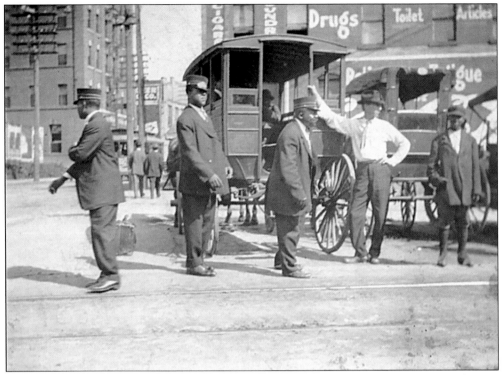

HOTEL HACKS. (Photoprint.) These porters, with their horse-drawn passenger vans, ferried guests to the Morgan Square hotels. Arriving passengers could walk to Magnolia Street hotels, such as the Gresham, shown on the left. By 1920, 60 passenger trains passed through each day. (Card courtesy of the Regional Museum of Spartanburg County.)

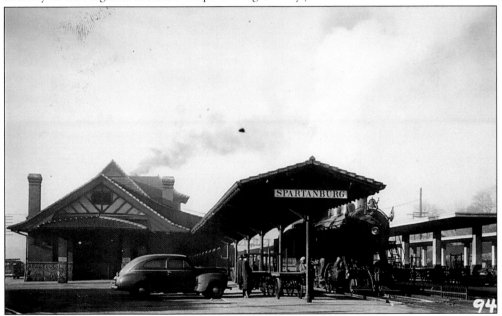

UNION STATION. (Photoprint, *c.* 1940.) As this card shows, the first section of the train station to disappear was the tower. (Card courtesy of Tommy Acker.)

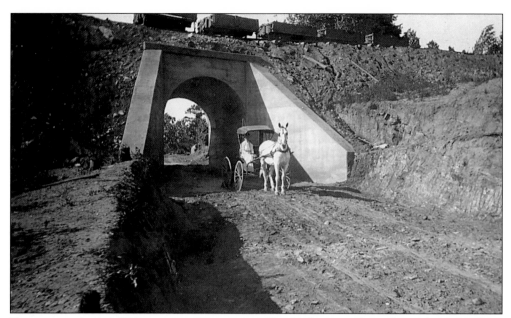

TUNNEL UNDER P & N RAILROAD. (Photoprint.) The Piedmont and Northern Electric Railway was the last to come to Hub City. Added in 1915, the line provided convenient and inexpensive service from Spartanburg to Greenville and on to Anderson and Greenwood. The Spartanburg station was on North Spring Street. The rail line's freight service brought raw materials to the area's textile mills and carried their products to markets. (Card courtesy of the Regional Museum of Spartanburg County.)

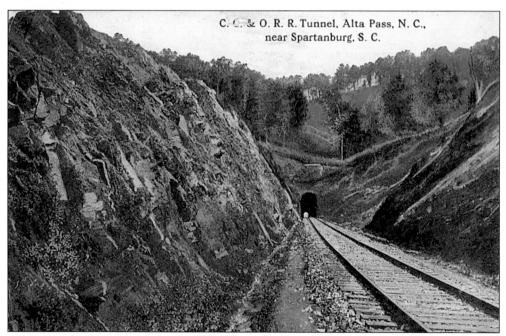

C.C. & O.R.R. TUNNEL, ALTA PASS, NEAR SPARTANBURG. (S.H. Kress & Co.) The Carolina, Clinchfield & Ohio was one of several rail lines that came through Spartanburg. (Card courtesy of Bill Littlejohn.)

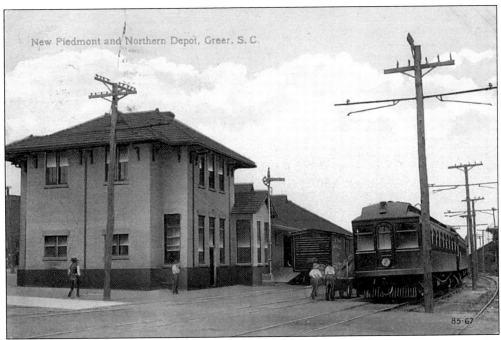

New Piedmont and Northern Depot, Greer, S. C.

85-67

NEW PIEDMONT & NORTHERN DEPOT, GREER, SC. (Valentine Souvenir Co, New York.) One of the stops by the P & N, on the way from Spartanburg to Greenville, was at Greer. This card, postmarked 1918, shows the depot shortly after its completion. An electric train waits on the track.

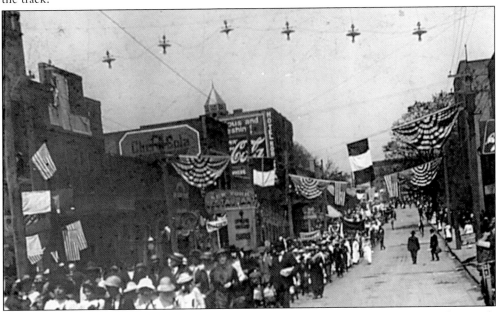

WORLD WAR I VICTORY PARADE ON MAGNOLIA STREET. (Photoprint, *c.* 1918.) The parade of schoolchildren and teachers is approaching Morgan Square. The cone-shaped top of the courthouse clock tower is seen in the skyline. Many of the buildings on the west side of the street are still standing. The east side is now a parking lot. (Card courtesy of the Regional Museum of Spartanburg Country.)

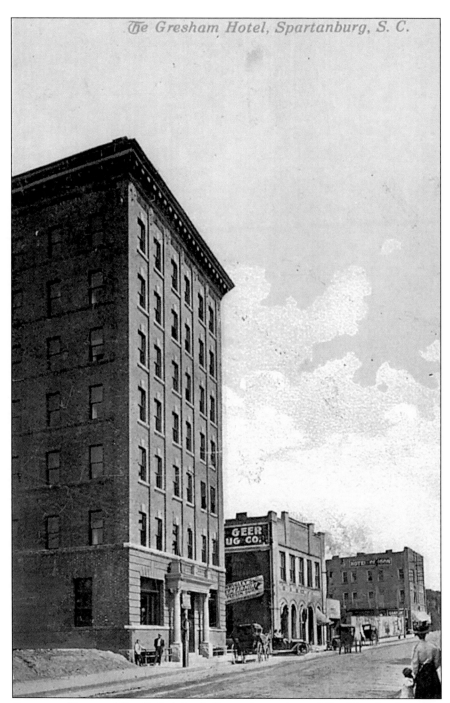

THE GRESHAM HOTEL. (The DuPré Book Store, Spartanburg, SC.) The Gresham Hotel was built in 1910 on Magnolia Street near the Union Depot. The seven-story building was the tallest in Spartanburg built with wooden framing. It had 100 rooms, 70 with private baths, and all with hot and cold water. After changing owners, the hotel was renamed the Morgan. It was demolished in 1986. The Geer Drug Company is to the right of the Gresham. The third building is the Hotel Normandy and is the only building, in this picture, standing today.

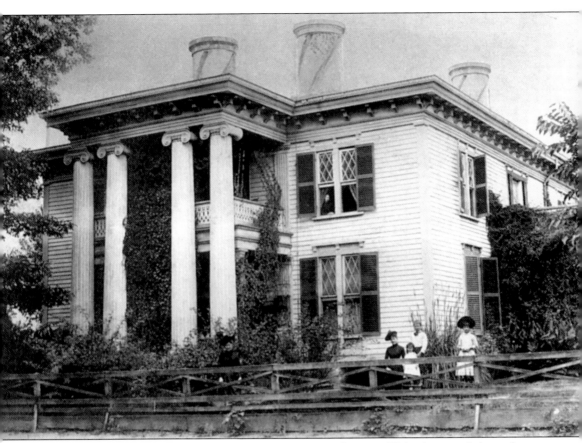

HOME OF LAFAYETTE AND CLARA TWITTY, MAGNOLIA STREET. This photograph is used to represent the stately residences which also occupied Magnolia Street, in addition to the hotels, public buildings, and train station. Unable to find gold in California or to support his family as a physician, Lafayette Twitty (1826–1885) settled in Spartanburg and became a merchandise broker. The home, in which he and Clara Mitchell Twitty lived on Magnolia Street, had the typical features of the classical revival style popular at the time: stately columns with Ionic capitals and a heavy denticulated cornice under the roof line. The diamond-pained upper window sashes were often used; however, the round chimneys were an unusual feature. The second-floor balcony had a very fine railing. The smallest girl in the picture is Clara Twitty Colcock, the granddaughter of Clara and Lafayette (accent on the second syllable) Twitty. Her future husband, Ben Hill Brown, was mayor of Spartanburg from 1925 to 1937. (Photograph courtesy of Ranny Brown.)

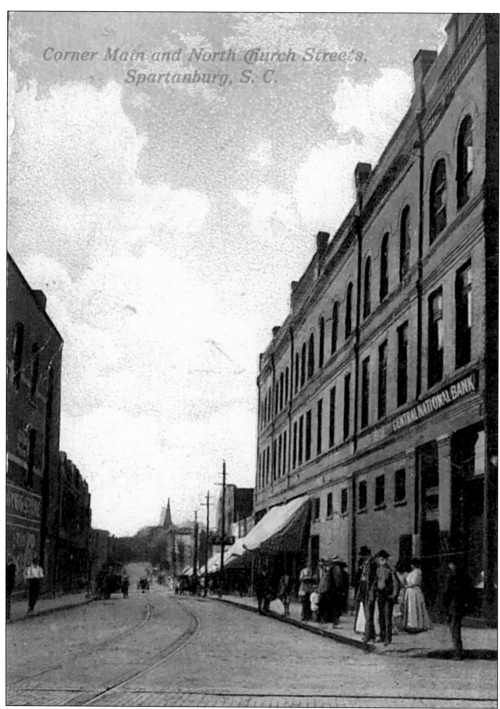

CORNER MAIN AND NORTH CHURCH STREETS. This card dates from about 1910 and gives a view down North Church Street from Main Street. The spire of Central Methodist Church is visible in the distance. The Palmetto Building, with a sign for the Central National Bank, is on the right. The buildings on the left were demolished when Church Street was widened in the late 1950s. (Card courtesy of Bill Littlejohn.)

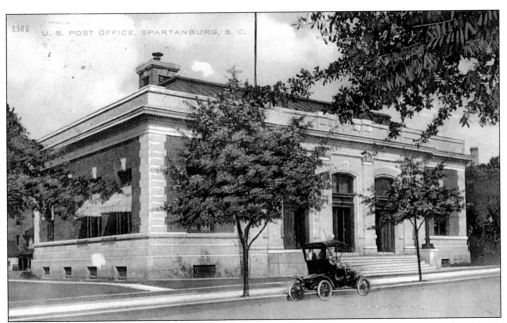

U.S. Post Office. (S.H. Kress & Co.) In 1906, a new post office was built on North Church Street. Bedford limestone was used on the facade of the fire-proof building. Ceasing to be a post office in 1930, it housed the Soil Conservation Service offices for many years. The building has now been demolished.

Montgomery Building. (Asheville Post Card Co., Asheville, NC.) In 1923, the Victorian home of John H. and Susan Ann Montgomery on North Church Street was demolished to build the town's second multi-story office building. The house was bulldozed into a hole and the building was constructed on top of it. The 1906 post office was across the street.

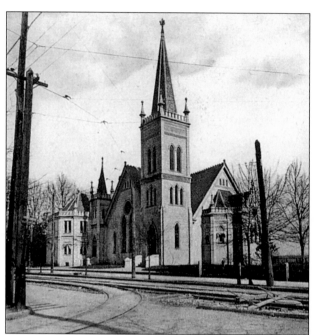

CENTRAL METHODIST EPISCOPAL CHURCH SOUTH. (The American News Co., New York.) Central is the oldest Methodist church in the city of Spartanburg. The present building is the third on the same site. The first was a somewhat flimsy wooden structure built in 1836.

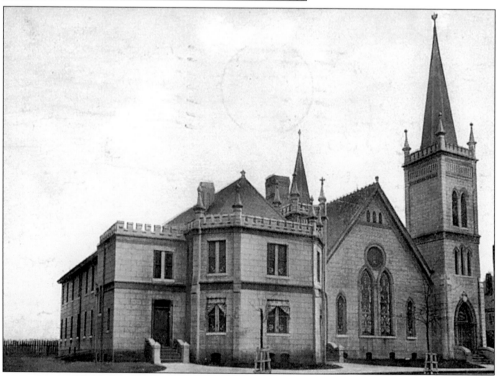

METHODIST CHURCH, NEAR CHURCH STREET. (International Post Card Co., New York, printed in Germany.) This card, which is postmarked 1909, shows Central Methodist Church's third building, which resulted from extensive reconstruction in the mid-1880s. Subsequently, alterations have been made to the facade, including an extension of the education building and removal of the large bay.

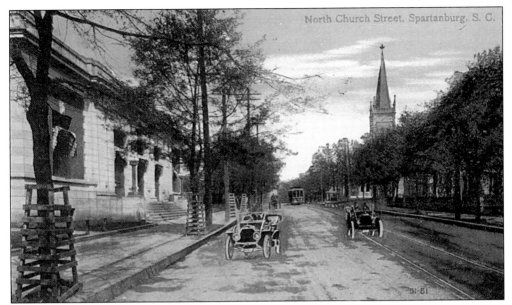

NORTH CHURCH STREET. (S.H. Kress & Co., *c.* 1915.) This scene of North Church Street, looking north, shows the 1906 post office on the left and the spire of Central Methodist Church in the distance. The wooden frames around the trees were to protect the trees from horses. Three means of transportation are shown; there are two of the new motorcars in the foreground and a trolley car and horse and carriage in the background.

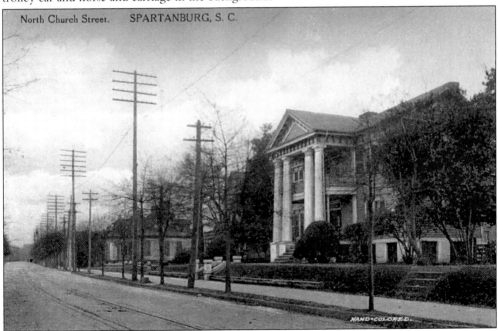

NORTH CHURCH STREET. (Postmarked 1911.) This imposing house has not been positively identified. The 1891 bird's-eye view of Spartanburg and the Sanborn Fire Insurance Maps both give evidence that the home was on the west side of Church Street in the block between the current bridge over the railroad tracts and West Charles Street, which is now Daniel Morgan Avenue. (Card courtesy of Gayle and Danny Russell.)

RESIDENCE OF MR. CHOICE EVINS. (Postmarked 1917.) This Greek-revival home was built in 1854, just beyond Wofford College, by physician and textile pioneer James Bivings. In 1869, Colonel John H. Evins, a nephew of the builder, bought the house. Jefferson Choice Evins was the third president of Clifton Manufacturing Co. from 1916 to 1945. He was married to Emma Twichell. Descendants still occupy the house.

BONHAVEN, HOME OF JOHN B. CLEVELAND, ESQ. (S.H. Kress & Co.) The home of John B. and Georgia Alden Cleveland was built in 1884 on North Church Street at the point where the Asheville Highway branches off today. The house was built in the style of the Second Empire, a popular Victorian design borrowed from the French during the reign of Napoleon III. The classical porticoes were added in the early twentieth century to update the house. This card is postmarked 1914. The house is still owned by the family. (Card courtesy of Bill Littlejohn.)

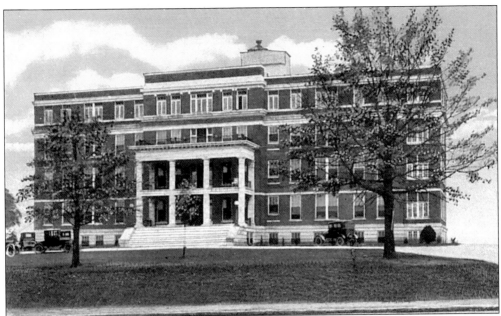

GENERAL HOSPITAL. (Southern Post Card Co., Asheville, NC.) Designed by Spartanburg architect J. Frank Collins, the General Hospital opened on North Church Street in August 1921. The new hospital provided space for 70 patients, and the circular drive in front provided all the parking that was needed.

GENERAL HOSPITAL AND NURSES' HOME. (Tichnor Bros., Boston, MA.) Built from 1923 to 1924, the Nurses' Home provided housing for unmarried nurses. Previously, they had lived on the fourth floor of the hospital.

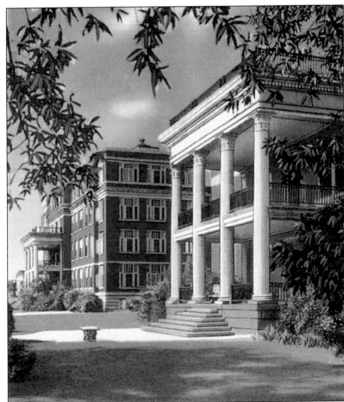

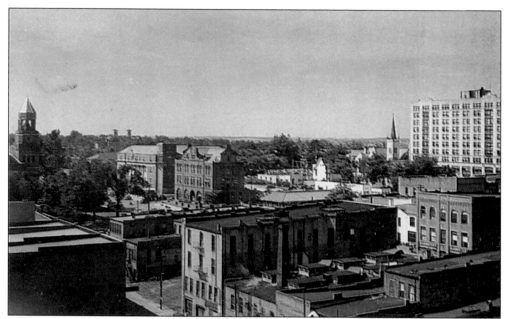

VIEW OF SPARTANBURG FROM CLEVELAND HOTEL. (Southeastern Paper Co. Spartanburg, SC.) On the far left is the tower of the fourth courthouse. Farther to the south on Magnolia Street are the 1930 post office and the Cleveland Law Range. On North Church Street, to the far right, are Central Methodist Church and the Montgomery Building.

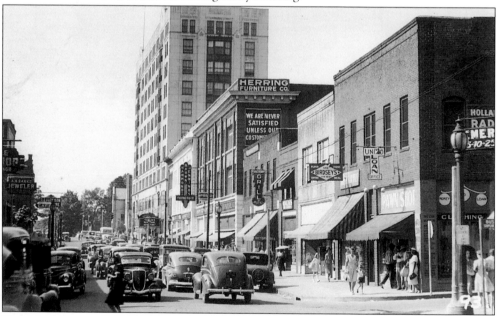

NORTH CHURCH STREET. (Photoprint, *c.* 1940.) This view is looking north from Morgan Square. The store, just this side of the Montgomery Building, is Hammond, Brown, Jennings Furniture Co. This longtime Spartanburg business was established in 1908 as Hammond, Brown, Wall Furniture Co. This card was mailed in November 1942 by a soldier at Camp Croft back home to his parents in Connecticut and contains the following message: "It has been pretty cold and raw down here."

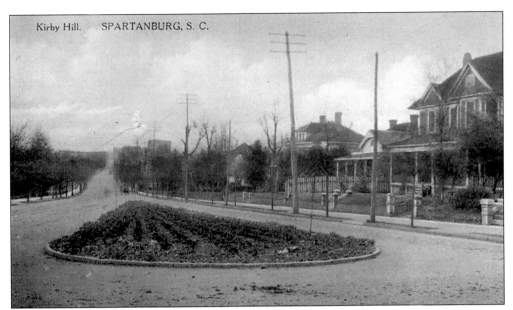

KIRBY HILL. (The Albertype Co., Brooklyn, NY.) Literally the high point of South Church Street was Kirby Hill, at the intersection of Henry and Church Streets. The spot takes its name from the nearby Kirby home, which was located where Bethel Methodist Church now sits. During improvements made to South Church Street in the early 1960s, the hill was partially leveled. This view, looking north toward town, is prior to 1910, before the Confederate Monument was erected. (Card courtesy of Tommy Acker.)

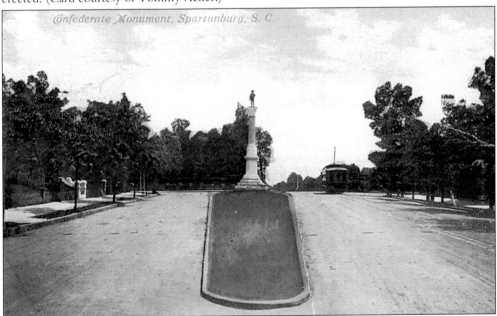

Confederate Monument, Spartanburg, S. C.

CONFEDERATE MONUMENT. (The DuPré Book Store, Spartanburg, SC.) This card is postmarked 1917 and shows the Confederate Monument erected on Kirby Hill in 1910. Ladies of the city were disturbed that no memorial had been established to the county's Confederate soldiers. They sold magazines and raised the necessary funds. In the early 1960s, the monument was moved to Duncan Park near the American Legion Lodge.

CITY HALL. Spartanburg's new city hall was built about 1914 on Broad Street. Its classical portico shows the neo-classical reaction to Victorian styles that occurred in the early twentieth century. (Card courtesy of Tommy Acker.)

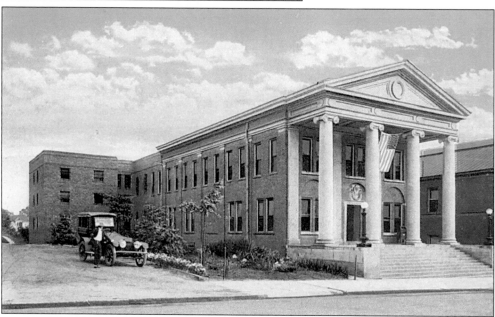

CITY HALL. (Southern Post Card Co., Asheville, NC.) The city jail was located on the back of the city hall. The "paddy" wagon, parked on the side, was converted from a hearse. This building was demolished in the late 1950s and the present city hall was built on the site.

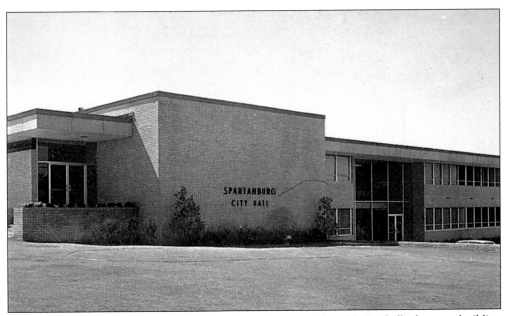

CITY HALL. (City News Agency.) Located on the site of the old city hall, the new building was completed in 1961. It houses the City administrative offices, Council Chamber, Police Department, Public Works Department, Fire Department, and City Jail. (Card courtesy of Graham Bramlett.)

HIGHLAND COURT APARTMENTS. (Southern Post Card Co., Asheville, NC.) The Highland Court Apartments were built in 1925 just down from Kirby Hill, at the corner of Henry and Spring Streets. They were one of Spartanburg's first multi-unit apartment complexes.

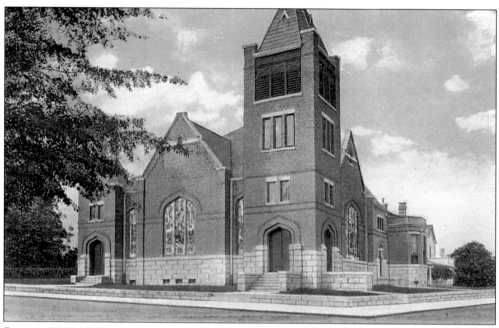

BETHEL M.E. CHURCH. (Southern Post Card Co., Asheville, NC.) Bethel Methodist Church was organized in 1856. Its second building, shown in this scene, was built in 1907 on South Church Street at the corner of Lee Street. In 1953, a new building was constructed facing Henry Street. The 1907 church was then taken down. This card was mailed in January 1918 by a lieutenant at Camp Wadsworth to a friend in Brooklyn, New York, and reads as follows: "It is cold as the devil here."

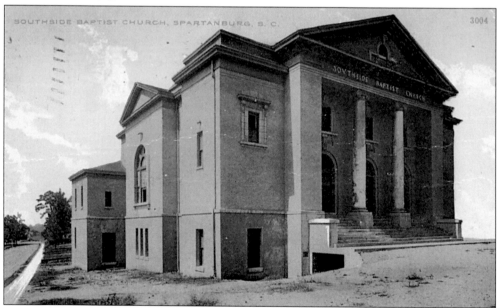

CHURCH STREET, SHOWING SOUTHSIDE BAPTIST CHURCH. (E.C. Kropp Co., Milwaukee.) Southside Baptist Church was founded in 1908. In 1911, this building was constructed on South Church Street. In 1982, it was demolished, and a new church was erected upon the same site. (Card courtesy of Gayle and Danny Russell.)

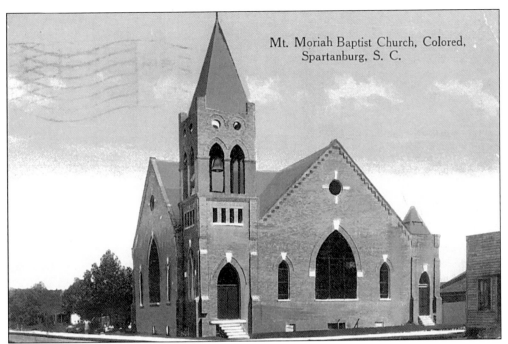

Mt. Moriah Baptist Church, Colored,
Spartanburg, S. C.

MT. MORIAH BAPTIST CHURCH. (Postmarked 1917.) Mt. Moriah was the first African-American Baptist church organized in Spartanburg and South Carolina. Established in 1870, it first occupied a wooden church. In 1913–1914, the brick building, shown in this scene, was constructed on the corner of South Liberty and Young Streets. In 1977, Mt. Moriah moved to a new home on South Church Street. The second church building was then taken down. (Card courtesy of Gayle and Danny Russell.)

HAMPTON AVENUE. (The Albertype Co., Brooklyn, NY.) Hampton Avenue is the principal street of the Hampton Heights neighborhood, which developed between 1890 and 1930. It consists of large Victorian residences as well as many early-twentieth-century bungalows. Named for the popular post-Reconstruction governor, Wade Hampton III, the neighborhood was designated a Historic District in 1983. (Card courtesy of Tommy Acker.)

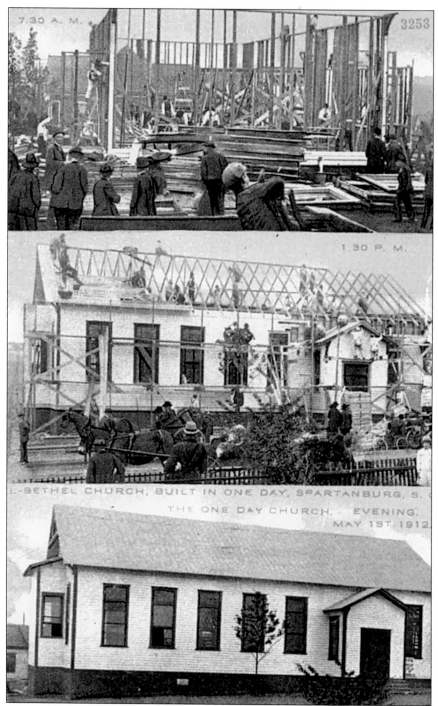

El-Bethel Methodist Church, the Church Built in a Day. (S.H. Kress & Co.) One day in 1912 a team of workers, donating their skills, completed this frame building in time for evening services. This card shows three stages in the progress. Located on South Church Street, the wooden building was replaced by a brick church in the 1950s. (Card courtesy of Gayle and Danny Russell.)

Three

MIDTOWN

This chapter will primarily cover the area from Church Street going east to Pine Street. As Spartanburg achieved new growth in the 1890s, the business area began to move east along Main Street. The first blocks east of Church Street were mainly commercial with stores and hotels. The area from Dean Street, and running east to Pine Street, first developed as a residential area with churches interspersed as well. Scenes along Liberty, Converse, Dean, Alabama, and Hall Streets are included. The south section of Hall Street would be renamed Advent Street. Prior to the 1950s, Pine Street came into East Main from the south and ended. North Pine Street was not created until the 1950s. East of Pine Street, Converse Heights developed as Spartanburg's first eastside subdivision in the first decade of the twentieth century. This area was regarded as being outside of town at the time. Mills Avenue and Otis Boulevard were the main thoroughfares of the new section.

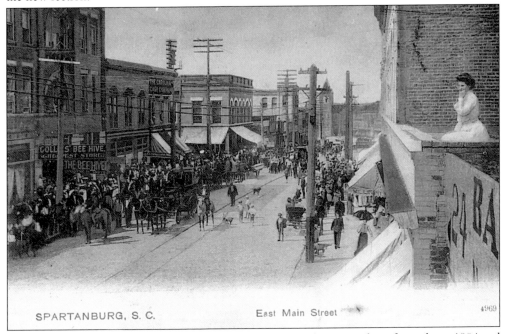

SPARTANBURG, S. C. East Main Street 4969

EAST MAIN STREET. (Paul C. Koeber Co., New York.) This scene dates from about 1904 and shows the first block of Main Street, east of Church Street. In 1910, Greenwald's moved into the building, with the large awnings, on the corner of Main and Church. The woman viewing the scene is on top of the two-story addition to the Palmetto Building, which was the first location of the Aug. W. Smith Company.

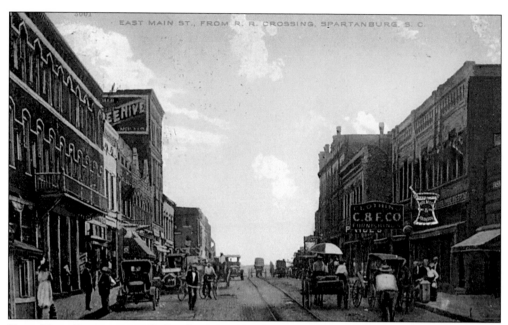

EAST MAIN STREET FROM R.R. CROSSING. (S.H. Kress & Co.) The Southern Railroad tracks running across East Main Street were removed in 1925. This scene, dating from about 1910, looks west toward Morgan Square. On the extreme left is the Argyle Hotel. S.H. Kress & Co. occupied the ground floor of the building.

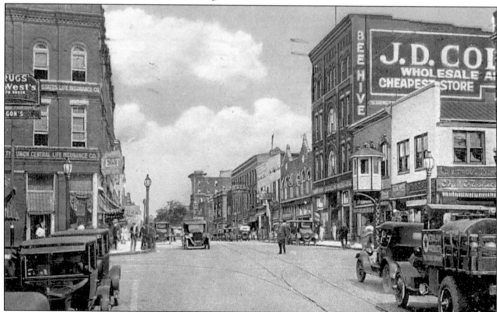

MAIN STREET, LOOKING EAST. (Asheville Post Card Co., Asheville, NC.) This picture, from the 1920s, shows the Palmetto Building on the left and, on the right, J.D. Collins Beehive Store, which advertised itself as "The Cheapest Store." The proprietor cautioned clerks, when wrapping parcels for customers, not to use too much string. The hut mounted on a pole, just below the Beehive's sign, was used by traffic wardens, who manually changed the traffic signal at Church Street.

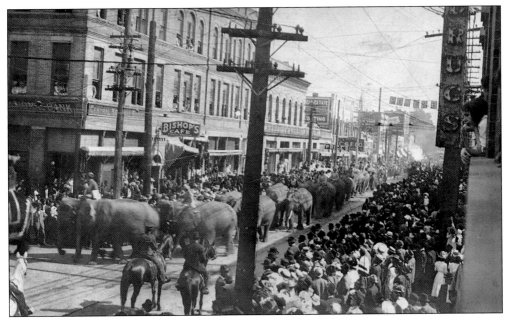

CIRCUS PARADE ON EAST MAIN STREET. (Photoprint.) The Barnum & Bailey Circus came to town in 1903. The parade of elephants is turning the corner from East Main Street into North Church Street. The two-story addition to the Palmetto Building still has its original second-floor windows, with rounded tops, before their replacement with modern glass. The sign for Price's Men's Store, founded in 1903, is in the middle of the picture. (Card courtesy of the Regional Museum of Spartanburg County, gift of Grantham Wood.)

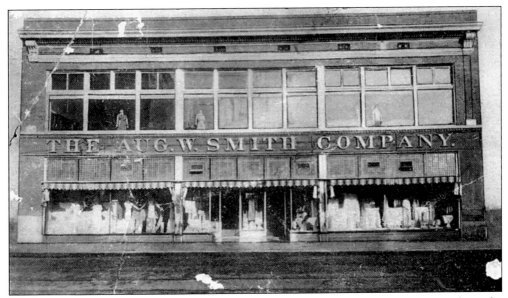

THE AUG. W. SMITH CO. (Photoprint, *c.* 1910.) After a two-story addition was made to the Palmetto Building on East Main Street, Augustus Wardlaw Smith moved his store from Abbeville to Spartanburg. Smith was more of a silent partner in the new venture. The co-owner, Frank McGee, was the person who actually established the company and made it into Spartanburg's premier department store. (Card courtesy of Bill Littlejohn.)

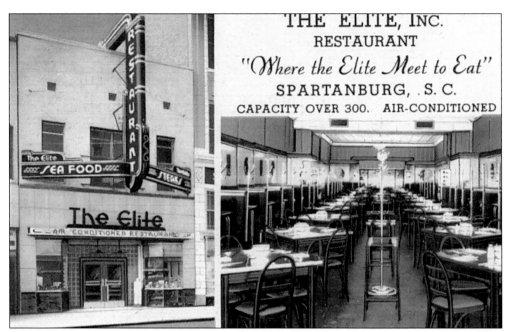

THE ELITE RESTAURANT. (Asheville Post Card Co., Asheville, NC.) Sometime in the 1920s, George Harakas purchased a fruit stand and ice cream parlor from Nick Trakas. In the early 1930s, he opened the Elite Restaurant to the left of S.H. Kress Five & Dime Store. Under Mr. George's management, the Elite became Spartanburg's most popular place to eat. In 1951, the Elite was converted to the W & W Cafeteria, which burned in 1961.

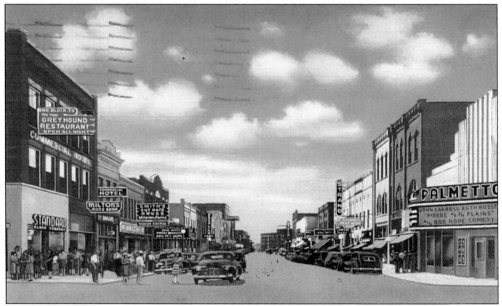

MAIN STREET, LOOKING WEST. (C.T. Art Colortone, Chicago.) East Main Street is shown from Liberty Street in the early 1940s. The Palmetto Theater was one of several movie theaters in this block. The Strand Theater is seen on down the street. On the left, the Commercial Hotel occupies the building which was the first location of Benjamin Steedley's private hospital. This card was mailed by a private at Camp Croft. No postage was required.

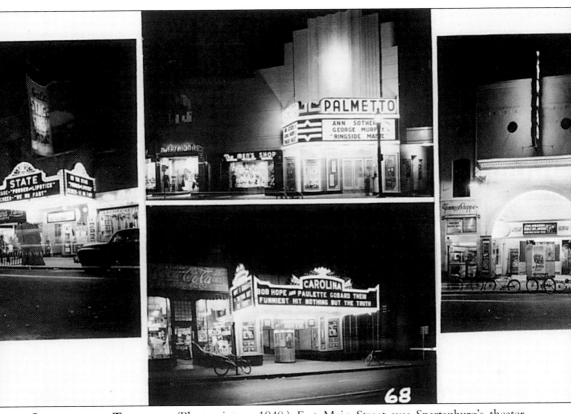

SPARTANBURG THEATERS. (Photoprint, *c.* 1940.) East Main Street was Spartanburg's theater district. One of oldest movie theaters was the Rex, located on the south side of Main Street. Like many picture palaces of the early part of the century, it was designed in the Moorish style. When it was renamed the State Theater (on the left in this card) in the 1930s, the new marquee obscured the building's Moorish features. The State Theater was sometimes used for traveling burlesque shows. The Strand Theater, on the right, was built about 1919 in the new Art Deco style. In this card, Bob Hope and Paulette Goddard are playing at the Carolina Theater (bottom center), which was opened in the Montgomery Building in 1925. A future California senator, George Murphy, shares billing with Ann Southern at the Palmetto Theater (top center). The Palmetto was the last of these theaters to survive. It was designed by Earl G. Stillwell of Hendersonville in the Art Deco style. Located on the corner of East Main and North Liberty Streets, the Palmetto opened in 1940 and closed in 1975. The building survives today without its marquee. (Card courtesy of Tommy Acker.)

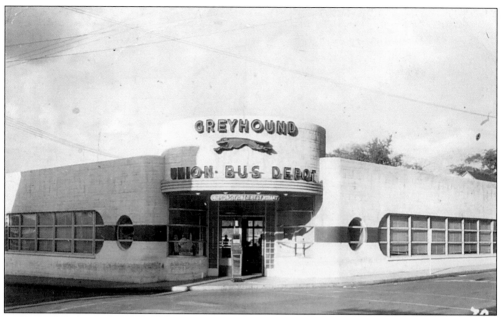

GREYHOUND BUS DEPOT. (Photoprint, *c.* 1940.) Built around 1940 at a cost of $35,000, the new bus station continued the Art Deco style so popular in the 1920s and 1930s. Located at the corner of North Liberty and Dunbar Streets, the site is now a parking lot. (Card courtesy of Tommy Acker.)

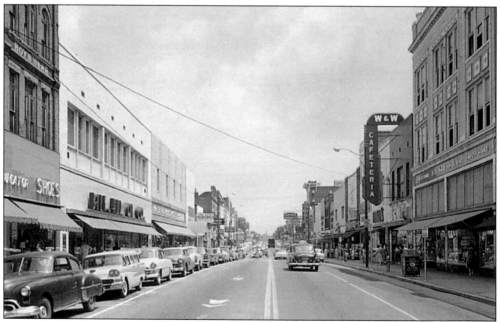

EAST MAIN STREET IN THE 1950s. (Colorpicture Publishers, Boston.) This view, looking east from Church Street, shows the changes that occurred by the 1950s. The Palmetto Building is on the extreme left. The Belk-Hudson Company occupies the space of Aug. W. Smith's first location. The W & W Cafeteria, operated by W.W. Bailey, occupies the former location of the Elite Restaurant. The site is currently a vacant lot. S.H. Kress is on the far right of the picture.

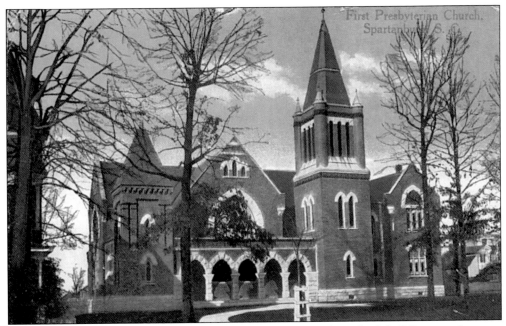

FIRST PRESBYTERIAN CHURCH. Presbyterians constructed their third building on the same site in 1900. Located on the corner of East Main and North Liberty Streets, the church had a design similar to the 1891 courthouse. This impressive building served the Presbyterians for less than 25 years. In 1925, the property was sold to developers and a new church was built farther east on Main.

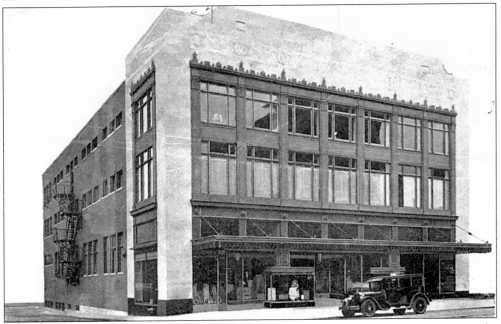

THE AUG. W. SMITH CO. Eventually, Spartanburg's "leading store" outgrew its premises in the Palmetto Building. About 1927, this new building was constructed on the site of First Presbyterian Church's demolished third building. The Aug. W. Smith Co. is now closed but its building is still standing on East Main Street.

HOTEL FINCH. (Southern Post Card Co., Asheville, NC.) About 1914, the Finch Hotel was opened on South Liberty Street. In the early 1920s, a larger extension was added, fronting on Main Street and forming an L-shaped structure. The Liberty Street building was demolished in the 1960s.

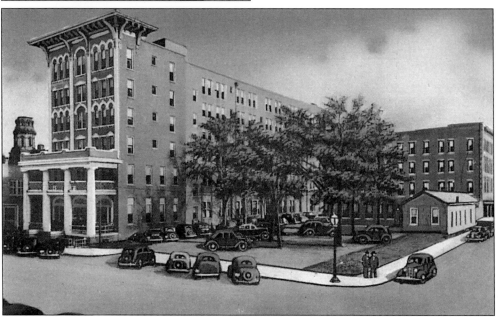

HOTEL FRANKLIN. (Asheville Post Card Co., Asheville, NC.) Soon after the addition was built, the Finch Hotel changed ownership. Perhaps it was the large stained-glass "F" over the new Main Street entrance that prompted the new owners to rename the hotel the Franklin. The original Finch Hotel is on the right on South Liberty Street.

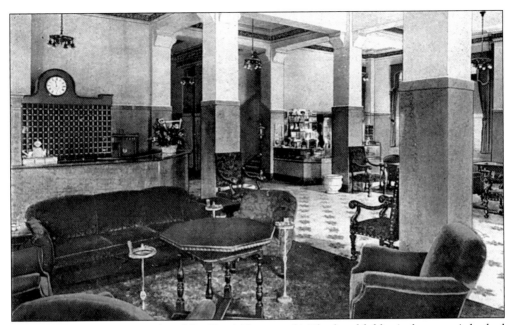

LOBBY, FRANKLIN HOTEL. (Franklin Hotel Newsstand.) The hotel lobby is shown as it looked in the 1930s. Newsstands were located in the lobby of most hotels at this time. The Franklin's newsstand is seen in the center background.

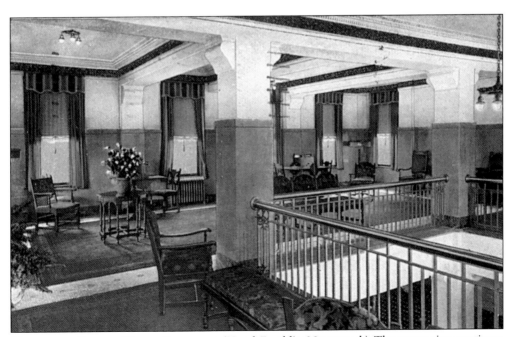

MEZZANINE FLOOR, HOTEL FRANKLIN. (Hotel Franklin Newsstand.) The mezzanine continues the 1930s decor of the lobby. The Franklin Hotel was imploded in 1988 early on a Sunday morning. It occupied part of what is now Richardson Park.

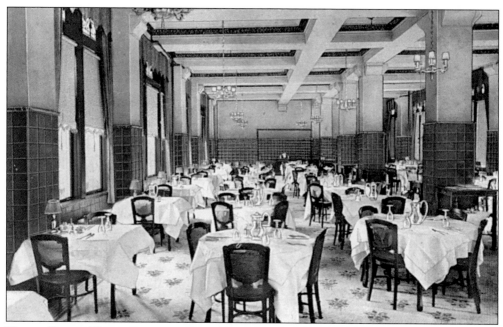

DINING ROOM, HOTEL FRANKLIN. (Hotel Franklin Newsstand.) More elegant hotels of the time used marble in their interiors. Tiling lines the walls of the Franklin's dining room.

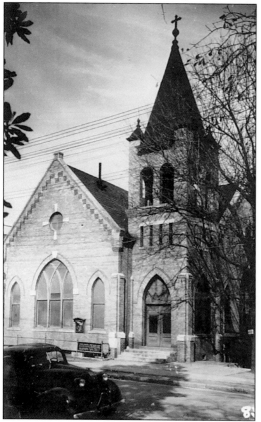

LUTHERAN CHURCH. (Photoprint, *c.* 1935.) The first Lutheran congregation in Spartanburg was organized in 1902. They constructed their first building on South Converse Street in 1909 at a cost of $8,000. The Gothic structure was named the Women's Memorial Evangelical Church. It was located behind the Southern Bell Building.

HERTZOG APARTMENT HOUSE.
(S.H. Kress & Co.) Jacob P. Herzog
built this structure to the right of
the future YMCA building about
1905. Apartment houses, such as
this, were beginning to replace the
boarding houses in which single
persons and young couples often
lived. The Hertzog Apartments
ceased to operate in the mid-1930s.

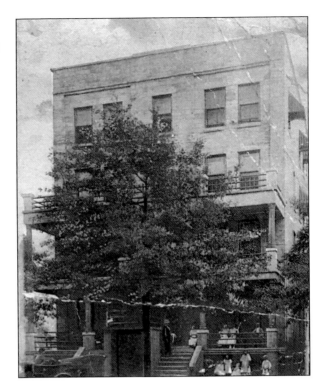

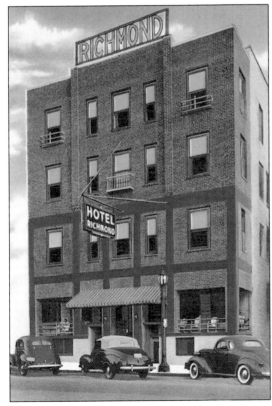

HOTEL RICHMOND. (Tichnor Bros.,
Boston.) After the Hertzog Apartments
closed in the mid-1930s, the building was
transformed into the Hotel Richmond,
with James B. Huggins as manager. A
shallow addition of red brick was attached
to the front. The entrance porch was left
open, but the porch on the second floor
was enclosed. The building stood where
the new connector from Broad Street
comes into East Main.

61

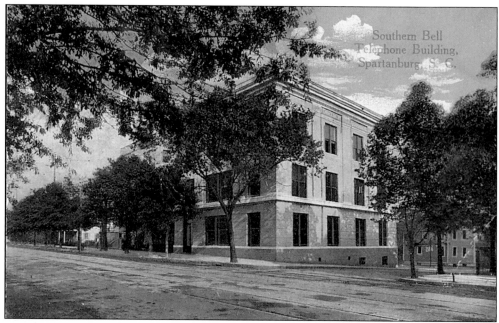

SOUTHERN BELL TELEPHONE BUILDING. (This card is postmarked 1917.) The Southern Bell Building was constructed in the early twentieth century. Later, when East Main Street was widened, the building protruded into the street and was eventually moved back. The telephone company would later move to a new building farther east on Main Street. Located on the corner of East Main and South Converse Streets, this building stood where there is now a small park.

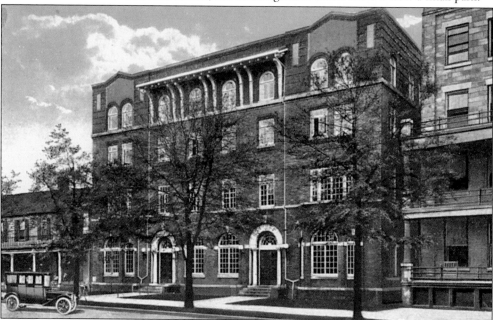

YMCA BUILDING. (Southern Post Card Co., Asheville, NC.) Located between Converse and Dean Streets on the south side of East Main, the new YMCA was built about 1916. It had the first indoor swimming pool in Spartanburg. The building was destroyed by an act of arson in the 1960s. The Hertzog Apartments can be seen on the right.

MAIN STREET MALL. (Photoprint, *c.* 1975, Photo Arts, Winnsboro, SC.) In 1974, East Main, between Church and Converse Streets, was closed to vehicular traffic and made into a pedestrian mall. In addition to a fountain, the mall had a reconstructed tower in which was installed the bell and clock that were once in the Opera House and later in the Magnolia Street Court House. In 1986, the block from Converse to Liberty Streets was reopened to traffic. In 1989, the tower was relocated to Morgan Square and the entire mall reopened to traffic. (Card courtesy of Ernest P. Ferguson.)

FIRST BAPTIST CHURCH. (The American News Company, New York.) After occupying churches on both Magnolia and North Church Streets, the Baptists built this Romanesque building of cream brick at the corner of East Main and North Dean Streets in 1904. Later an arcade would connect it with an education building. The church was destroyed by an act of arson in 1962.

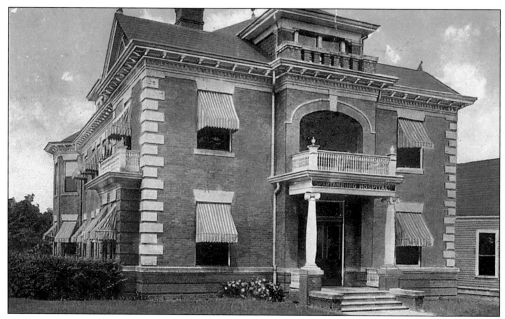

SPARTANBURG CITY HOSPITAL. (Southern Post Card Co., Asheville, NC.) Spartanburg's first City Hospital was on North Dean Street, behind the First Baptist Church. When the hospital moved to North Church Street in 1921, John B. Cleveland acquired the old building and offered it for use as a home where older women could live at a moderate cost. Cleveland's deceased wife, Georgia Alden Cleveland, had headed a committee to establish such a home. The Georgia Cleveland Home closed in 1998. The building is now used for the St. Luke's Free Clinic. (Card courtesy of Tommy Acker.)

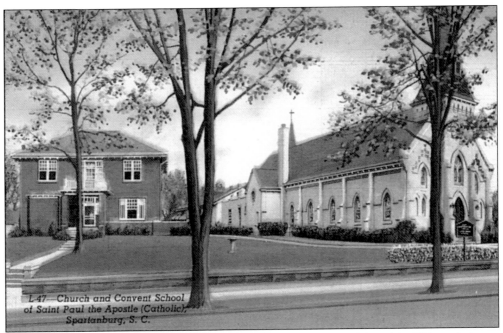

CHURCH AND CONVENT SCHOOL OF SAINT PAUL THE APOSTLE. (Curteich, Chicago.) Across from the City Hospital on North Dean Street, Saint Paul's Catholic Church was built in 1884 in the same style as St. Patrick's Church in Charleston, which was built three years later. The *Carolina Spartan* stated the following: "Dean Street may well be proud if this beautiful improvement." The Convent School has now been replaced by a modern building.

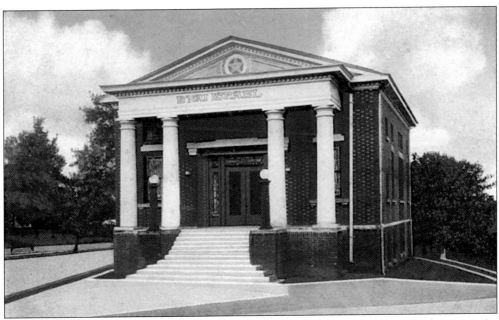

B'NAI ISRAEL TABERNACLE. (Carolina Card Co., Asheville, NC.) In 1917, the Jewish community built this classical-revival synagogue on a triangular lot where Union Street joins South Dean Street. The building is no longer used by a Jewish congregation.

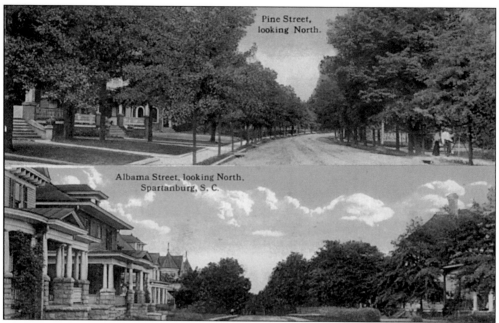

PINE STREET LOOKING NORTH/ALABAMA STREET LOOKING NORTH. (C.T. Photochrom.) These scenes, from about 1900, show both Pine Street and Alabama Street as narrow, tree-lined roadways with substantial residences. Pine Street came into East Main from the south and ended. North Pine Street was not created until the 1950s.

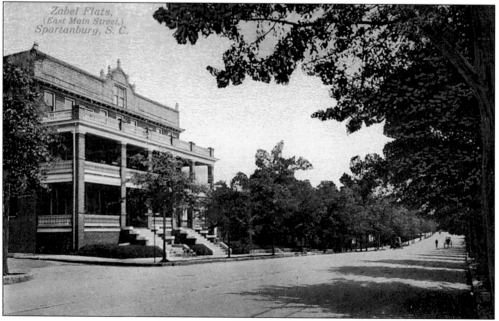

ZABEL FLATS, EAST MAIN STREET. (The DuPré Book Store, Spartanburg, SC.) The DuPré Book Store, established in 1852, had a number of town scenes printed as postcards. The Zabel Apartments were on the north east corner of East Main and Alabama Streets and provided both apartments and rooms for rent. The location is now parking and businesses.

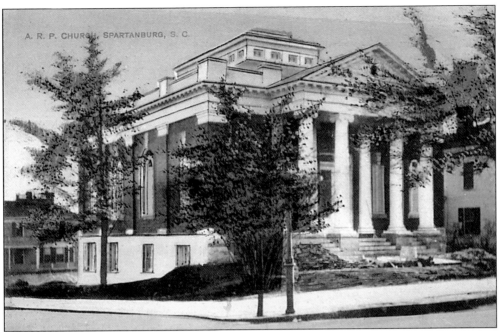

A.R.P. CHURCH. (The DuPré Book Store, Spartanburg, SC, printed in Germany.) In 1905, an Associate Reformed Presbyterian congregation was organized. The next year it purchased from Mr. M.G. Stone a lot on the corner of East Main and Advent Streets for $3,250. A handsome church, with a well-defined classical portico, was built in 1909. It was demolished in the 1980s and replaced by the NationsBank.

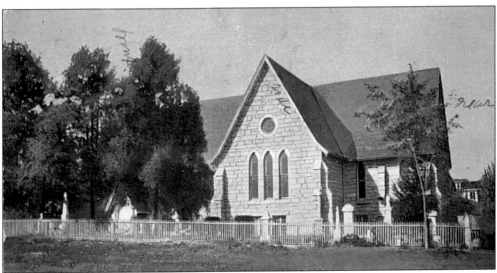

CHURCH OF THE ADVENT. (Raphael Tuck & Sons' Post Card Series No. 2389, undivided back.) The first Episcopal congregation in Spartanburg was organized in 1848. The construction of the church was not finished until 1864. It is the oldest church building in the city of Spartanburg. In this view, the church is facing toward Kennedy Street. The original entrance was on the left. Later the west end of the building was extended and a vestibule added, with a new entrance on Advent Street.

THE ALEXANDER HOUSE. (Asheville Post Card Co., Asheville, NC.) The home of Alonzo M. and Cecilia Alexander was located at 319 East Main Street and dates from the early part of the twentieth century. A.M. Alexander operated the Alexander Music House. Large oak trees lined both sides of Main Street. The house is now a business premise.

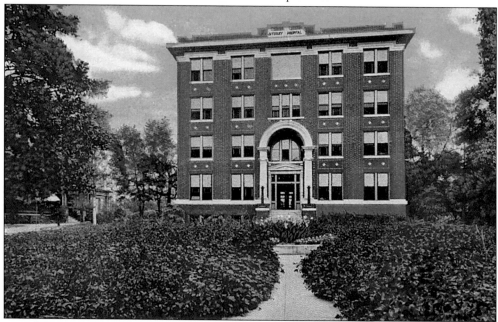

THE STEEDLEY HOSPITAL. (Carolina Card Co., Asheville, NC.) In 1910, Benjamin B. Steedley opened a private hospital at the corner of East Main and Liberty Streets. About 1916, he built the larger facility, shown in this card, on East Main, just east of Advent Street. In 1921, the Steedley Hospital merged with the new City Hospital. The building served as a YWCA and then became the Wellington Apartments. The site is now occupied by Duke Power Company.

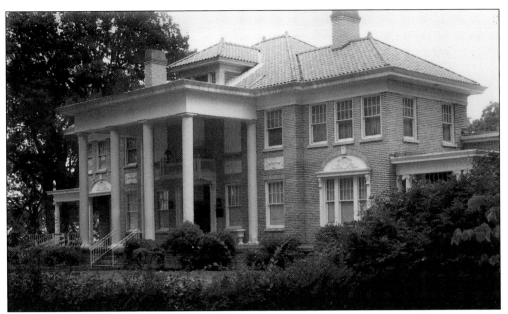

GERTRUDE DuPRÉ BURNETT HOUSE. (Photograph.) About 1920, Gertrude Burnett built this house on East Main Street. Her father was Warren DuPré, a member of Wofford College's first faculty. Her husband was Wilbur Emory Burnett, president of the First National Bank and vice president of Spartan Mills. After his death, Gertrude Burnett built this house on the site of their earlier home. The original Ionic columns have been replaced.

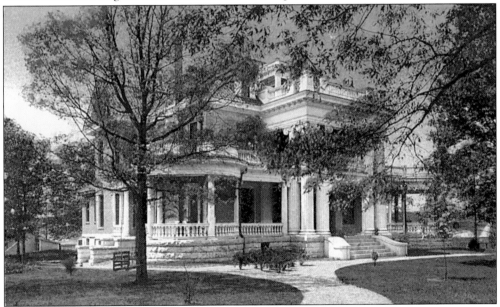

RESIDENCE OF W.S. MONTGOMERY. (Carolina Card Co., Asheville, NC.) The home of Walter S. Montgomery and Bessie G. Montgomery, built on Pine Street in 1910, is an example of the transition from Victorian designs to the neo-classical style of the early twentieth century. W.S. Montgomery (1866–1929) was the son of John H. and Susan Montgomery. The home has been restored and successfully converted for offices by Phyllis B. DeLapp and the late William Buchheit.

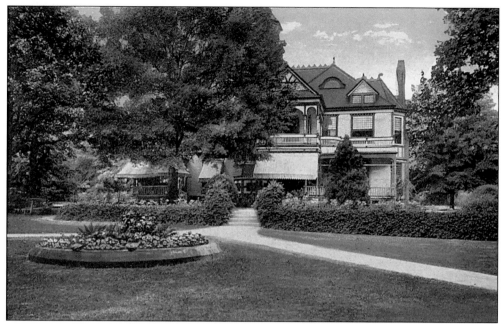

Twichell Residence. (Southern Post Card Co., Asheville, NC.) The home of Albert H. and Mary B. Twichell was built at the corner of Pine Street and Glendalyn Avenue in 1882. Albert Twichell was associated with his brother-in-law and first cousin, D.E. Converse, in the mills at Glendale and Clifton. Shortly after his death in 1916, the house was acquired by the Fretwell family. It was razed in 1979 for business use.

Spartanburg County Public Library. (City News Agency, Spartanburg, SC.) In 1947, the Kennedy Free Library on Magnolia Street was given tax support and became the Spartanburg Public Library. In 1961, it moved into this modern building on South Pine Street, which was on the site of the Victorian home of Edgar and Helen Converse. In 1997, the library moved again into a new building on South Church Street. The building in this card is being converted for business use. (Card courtesy of Graham Bramlett.)

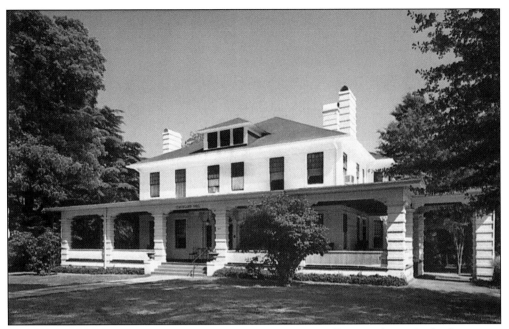

CLEVELAND ALUMNAE HOUSE. (Published by H.K. Barnett, Allison Park, PA.) This home was built on East Main at the corner of Mills Avenue in 1905 by Aug. W. and Belle Smith. In 1917, the Smiths moved to Greenville, when he became president of Brandon Mills. The house was then acquired by Floyd L. and Carrie Liles. In 1927, Arthur F. and Chevillette Cleveland came into possession of the home until the 1970s. Their heirs gave the home to Converse College.

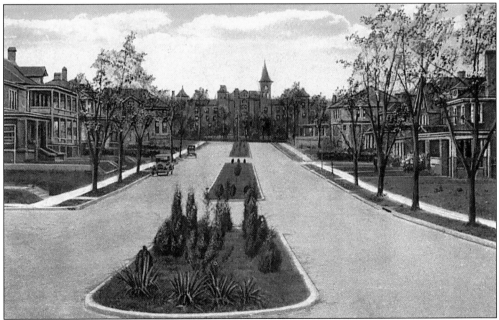

MILLS AVENUE, LOOKING TOWARD CONVERSE COLLEGE. (Southern Post Card Co., Asheville, NC.) Mills Avenue is the principal street of Converse Heights, a development that was opened in 1906 on what was originally part of the plantation of Major Govan Mills (1805–1862). Purchasers of lots were bound to spend a minimum of $1,500 on the construction of a house.

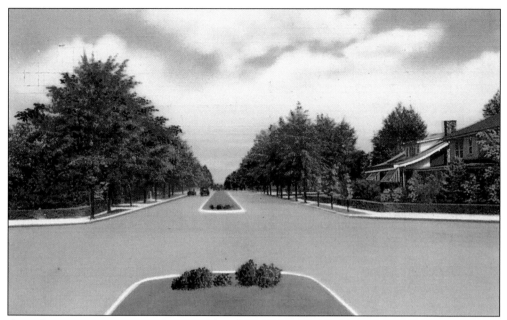

OTIS BOULEVARD, LOOKING EAST. (Asheville Post Card Co., Asheville, NC.) Otis Boulevard is the principal east-west road of Converse Heights. This view shows its intersection with Mills Avenue. Like Mills, Otis Boulevard has two lanes divided by a medium.

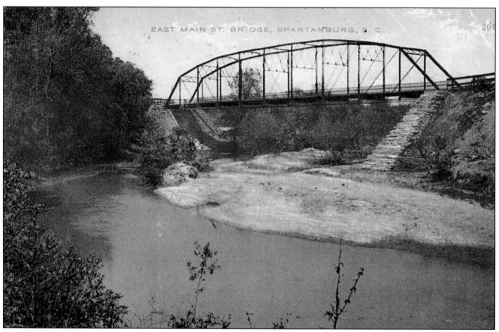

EAST MAIN STREET BRIDGE. (S.H. Kress & Co.) This card, postmarked 1912, shows the bridge over Lawson's Fork Creek in the early twentieth century.

Four

SCHOOLS AND COLLEGES

Economic development and progress in Spartanburg County have been closely tied to the educational opportunities that were established early in the area's settlement. The first schools in the county were one-room academies, the first of which might have been Rocky Spring Academy near Walnut Grove Plantation. It was established about 1770 by Charles Moore and other early British settlers and was in operation until 1850. Similar schools were established at Poplar Springs, Flint Hill, and Pine Grove. There was also a Minerva School, which was possibly associated with Nazareth Presbyterian Church, the earliest church in the county. By 1850, all of these academies seem to have ceased to function. Spartanburg quickly became the center of learning as graded schools replaced the one-room schools.

The establishment of Wofford College for men in the 1850s was of great significance to the town's development. Future generations of town leaders came and stayed in Spartanburg because of Wofford, and businesses and families came to the area because of the new opportunities. The establishment of a higher institution for men raised the question of higher learning for women. In 1855, the Spartanburg Female College was founded, as a joint effort of the South Carolina Methodist Conference and citizens of Spartanburg. The school did not prosper and closed after the Civil War. Higher education for women was finally made secure by the establishment of Converse College in 1889.

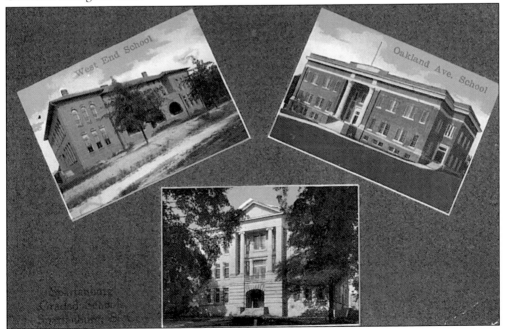

SPARTANBURG GRADED SCHOOLS. (S.H. Kress & Co.) Postmarked 1917, this card shows three schools established in the early twentieth century: the West End School, the Oakland Avenue School, and (on the bottom) the South Side School. (Card courtesy of Graham Bramlett.)

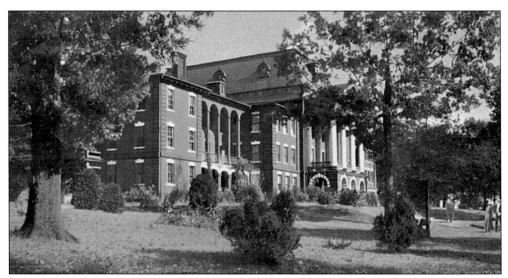

STATE DEAF AND BLIND INSTITUTE, CEDAR SPRINGS. (Raphael Tuck & Sons Post Card Series, printed in Germany.) In 1849, the Reverend Newton Pinckney Walker opened a school for deaf children. In 1855, instruction for the blind was added. In 1857, the State of South Carolina purchased the school from the Reverend Mr. Walker and made plans to construct the large central building shown in the two cards on this page. The view above is from the 1890s.

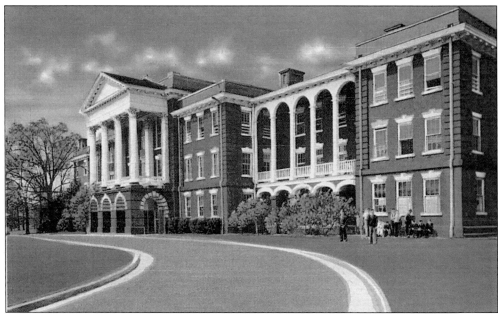

CEDAR SPRINGS SCHOOL FOR THE DEAF AND BLIND. (Asheville Post Card Co.) The central pavilion and east wing of Walker Hall were built in 1859. The heavy mansard roof over the central section, shown in the first card, was added in 1880; the west wing was added in 1884. In 1917, the mansard roof was removed. The view above is from the 1930s and shows the exterior painted red.

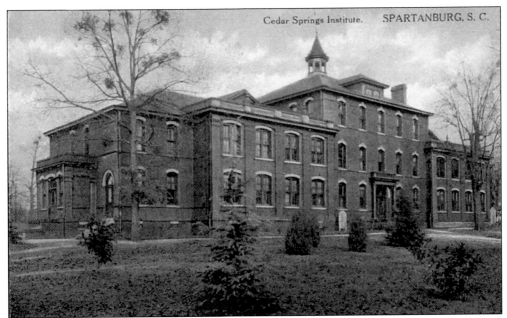

GIRL'S DORMITORY, CEDAR SPRINGS INSTITUTE. (The Albertype Co., Brooklyn, NY.) This building was added in 1903 and served briefly as a school before being converted into a Girls' Dormitory. Female teachers also lived in the building. The steeple housed the school bell, and a chapel was on the top floor of the central section. The building was taken down in 1948 and replaced by Hughston Hall.

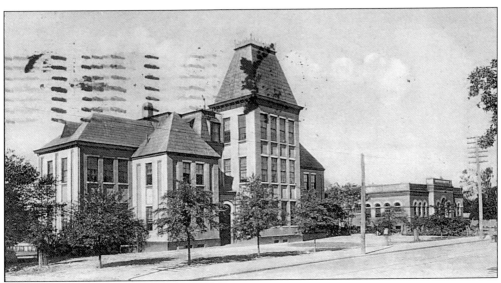

MAGNOLIA STREET GRADED SCHOOL. (Paul C. Koeber Co.) Built in 1889, the Magnolia Street Graded School was Spartanburg's first public school. Located to the right of the fourth courthouse, the building was taken down in the late 1950s to build the current Spartanburg County Court House. One of the young scholars educated at the Graded School was future Spartanburg pharmacist Lionel D. Lawson. The smaller building beyond the school is the Kennedy Free Library.

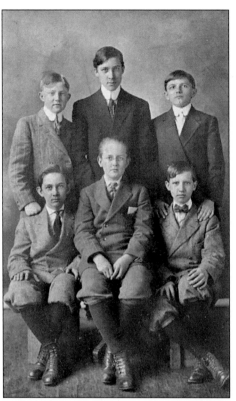

CLASS TWO, 1911—HASTOC SCHOOL. The Hastoc School was a private high school for boys and was located on St. John Street. Although none of the boys in this picture are identified, one student educated at the school was Walter Scott Montgomery (1900–1996). (Card courtesy of the Regional Museum of Spartanburg County.)

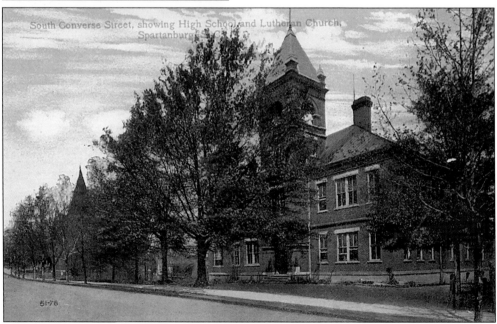

SOUTH CONVERSE STREET, SHOWING HIGH SCHOOL AND LUTHERAN CHURCH. (S.H. Kress & Co.) Spartanburg's first high school was built in 1897. The city was especially proud of the school's six classrooms. In 1910, W.G. Blake was principal. The spire of the Lutheran Church can be seen on the left.

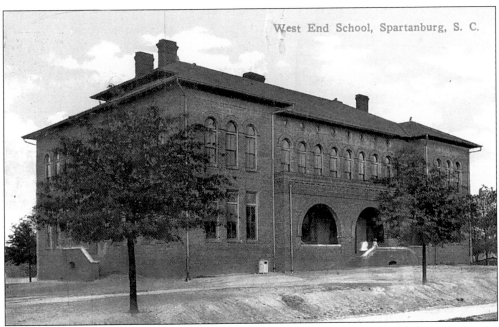

WEST END SCHOOL. West End School was built on Forest Street in 1892. In 1965, the school was closed and then became the Spartanburg School for Handicapped Children, before the organization of the Charles Lea Center. Today the building houses the Downtown Rescue Mission.

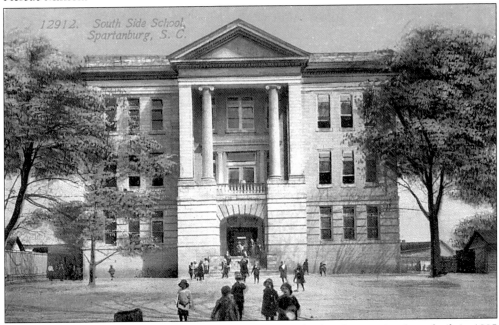

SOUTH SIDE SCHOOL. (The Acmegraph Co., Chicago.) This handsome school was built in 1905 on South Church Street. In 1939, a large addition was constructed for a junior high school. A few years later, in 1942, the school was renamed Jenkins Junior High after Superintendent Lowry W. Jenkins. Although the school was closed in 1974 and the buildings demolished, members of the faculty continued to meet for the next 25 years.

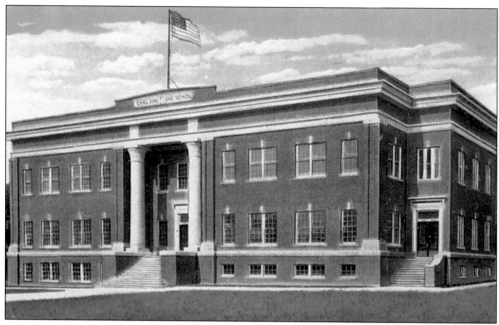

OAKLAND AVENUE SCHOOL. (Southern Post Card Co., Asheville, NC.) The Oakland Avenue School opened in 1911 just off East Main Street. In 1924, Miss Lettie Galbraith developed at Oakland an early program for mentally handicapped students. The school closed in 1959 and was demolished in the 1960s. The site is occupied today by the Main Branch of Wachovia Bank.

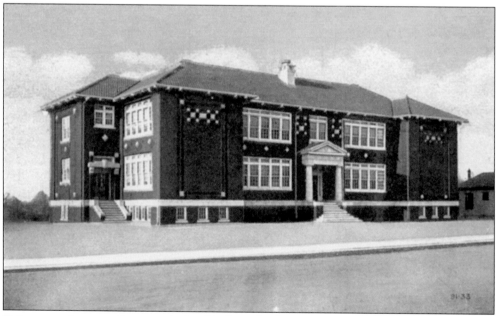

FREEMONT AVENUE SCHOOL. (Asheville Post Card & Pennant Co., Asheville, NC.) The Freemont Avenue School opened in 1914 and closed in 1979. Today the building is used by the Downtown Rescue Mission as a thrift shop.

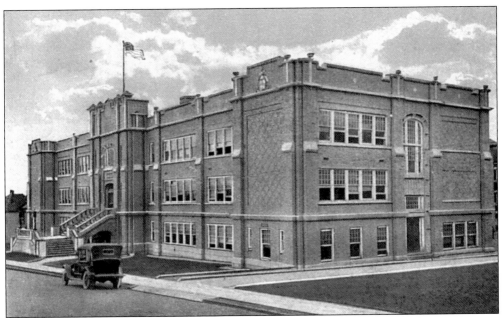

FRANK EVANS HIGH SCHOOL. (Southern Post Card Co., Asheville, NC.) In 1921, local architect J. Frank Collins designed a new high school, with an elaborate stone entrance balustrade, on South Dean Street at a cost of $300,000. Large additions were made facing Kennedy Street in 1924 and 1928. Named for Frank Evans, who was school superintendent from 1895 to 1934, the school became a junior high in 1959. Today the building houses the Spartanburg Human Resource Center.

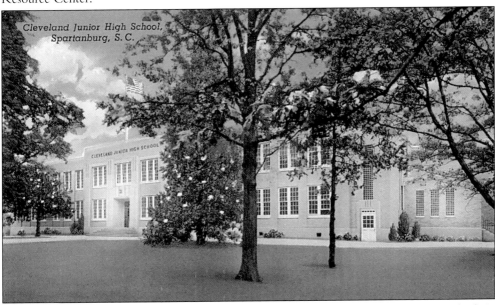

CLEVELAND JUNIOR HIGH SCHOOL. (Curteich, Chicago.) Cleveland Junior High was built in 1939 on land once occupied by the home of Jesse Franklin Cleveland on Howard Street. Dr. Cleveland's house was the twin of his brother's home (Bonhaven), shown on page 42. Becoming an elementary school in 1978, the building is currently under demolition. A new Cleveland Elementary School is being constructed on the site.

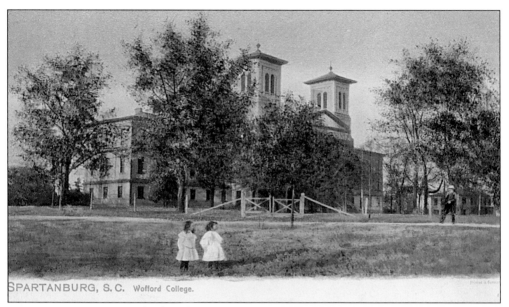

WOFFORD COLLEGE. (Raphael Tuck & Sons Post Card Series.) Wofford College opened in 1854 after a grant of $100,000 from the Reverend Benjamin Wofford. Although born into poverty, Benjamin Wofford, through marriage and astute business practices, acquired a fortune.

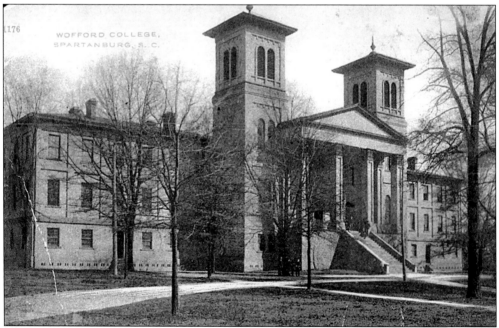

WOFFORD COLLEGE MAIN BUILDING. The Main Building was designed by Charleston architect Edward C. Jones in the Italianate style popular in the 1850s. The narrow steps replaced the original steps that spanned the entire entrance portico. In the 1950s the building was extensively renovated, the entrance steps were widened again, and a "second front" was put on the opposite side.

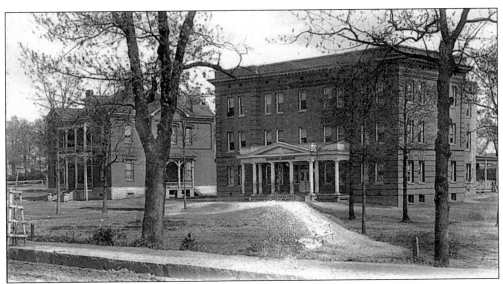

ARCHER HALL & WOFFORD FITTING SCHOOL. (The Rotograph Co., New York.) The building on the left was originally Alumni Hall, built in 1888 to house students. After a fire destroyed the top two floors in 1901, it was reconstructed as a two-story building and renamed Archer Hall. In 1953, when the Black family underwrote its renovation, the building was renamed Hugh S. Black Hall. Today, minus its porches, it houses the Admissions and Financial Aid Offices.

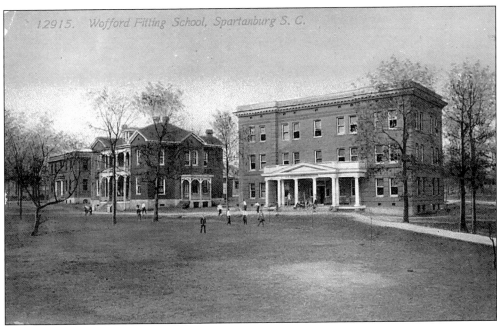

WOFFORD FITTING SCHOOL. (The Acmegraph Co., Chicago.) In 1887, the Fitting School was opened in the old Spartanburg Female College building on Forest Street to prepare students for entrance to Wofford College. In 1906, the building, shown on the right in this card, was constructed next to Archer Hall. When the Fitting School was closed in 1924, the building was renamed Snyder Hall and became a college dormitory. It was taken down in 1969.

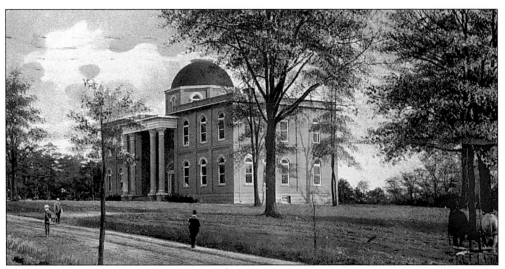

CLEVELAND SCIENCE HALL, WOFFORD COLLEGE. (Raphael Tuck & Sons Post Card Series.) Built in 1904 on the site of the old ball field, the Cleveland Science Hall was the result of a $25,000 contribution by John B. Cleveland (Class of 1869). Professor Daniel A. DuPré, head of the Science Department, asked Cleveland for the donation. The dome housed the only planetarium in the state. The building was taken down in 1959 and replaced by the Milliken Science Hall.

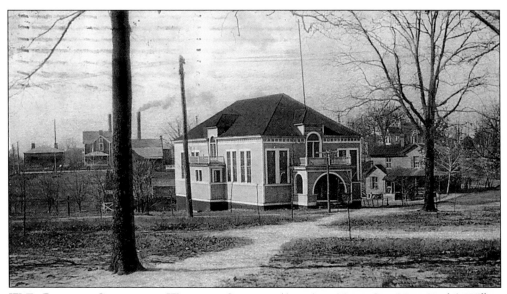

W.E. BURNETT GYMNASIUM, WOFFORD COLLEGE. (American News Co., New York.) Wilbur Emory Burnett was an 1876 graduate of Wofford and benefactor of his alma mater. He was the cashier and then president of the First National Bank, one of the founders of Spartan Mills, and involved in many other area enterprises. The gymnasium was located near Church Street. The smoke stacks of Spartan Mills can be seen in the background. The gymnasium is no longer standing.

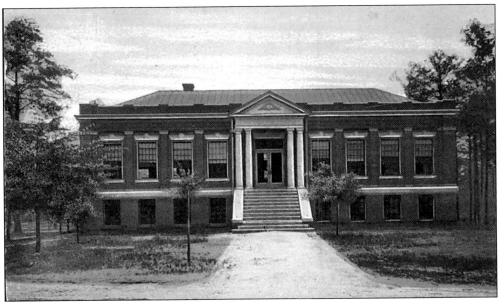

WHITEFOORD SMITH LIBRARY. Wofford College's library was built in 1910 and named in honor of Whitefoord Smith, a professor of English literature and elocution from 1856 to 1893. Wings on both ends and new entrance steps were later added. In 1970 the building was rebuilt on the inside and is now used for faculty offices and classrooms. This card is postmarked 1917.

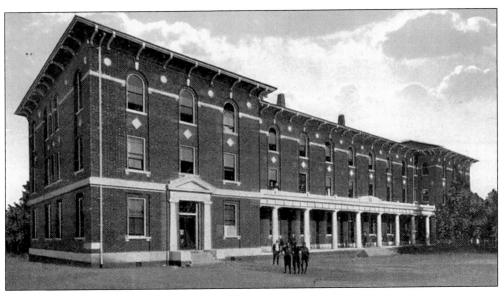

CARLISLE MEMORIAL HALL, WOFFORD COLLEGE. (Southern Post Card Co., Asheville, NC.) Opened in 1912 at a cost of $55,000, Carlisle Hall was Wofford's first real dormitory. Previously, some students had lived in boarding houses. The new dormitory was named in honor of James Henry Carlisle, a member of Wofford's first faculty and president from 1875 to 1902. Mrs. L.G. Osborne was the first matron. The building was taken down in 1982.

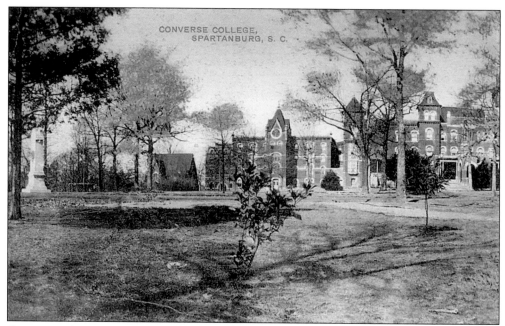

CONVERSE COLLEGE. (DuPré Book Store, Spartanburg, SC.) Converse College was established in 1889 by a group of Spartanburg citizens and named in honor of Dexter Edgar Converse, a contributor and textile executive. On the site, there had been several previous efforts to establish schools, one of which was St. John's Episcopal Seminary. St. John's Chapel is the small building on the left in this early view.

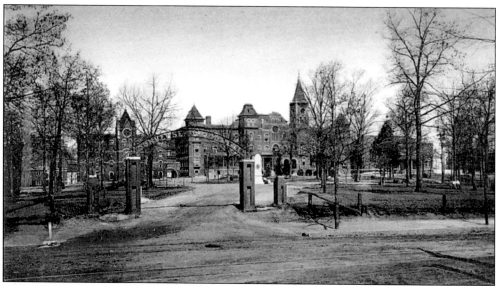

CONVERSE COLLEGE. (DuPré Book Store, Spartanburg, SC.) This view of the new college from East Main Street shows a metal sign, which spanned the pillars of the entrance gate and proclaimed the college's name. Note that East Main was unpaved in this early-twentieth-century scene. (Card courtesy of Graham Bramlett.)

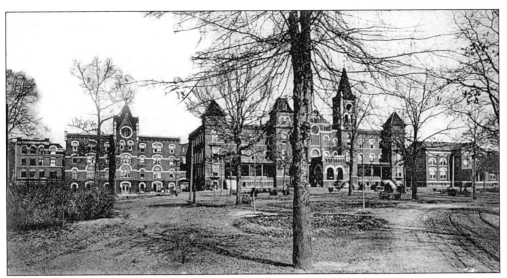

CONVERSE COLLEGE. When the property was purchased from the Episcopal Diocese in 1889, only the wings of the Main Building had been completed. The college trustees added a third floor and towers to the wings and constructed a central section to create Main Hall (later renamed Wilson Hall after the first president). The building on the far left is Dexter Dormitory, which had a gymnasium on the first level. The next structure on the left was called the Annex (now Pell Dormitory).

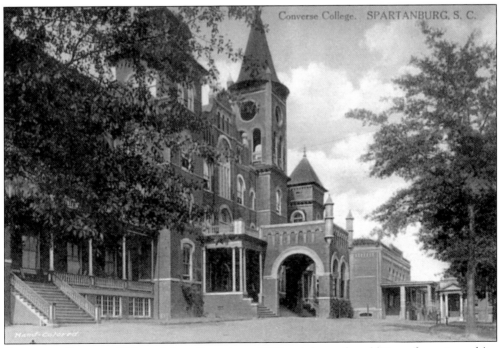

CONVERSE COLLEGE. This card dates from about 1910 and shows the addition of a porte cochère at the entrance to Wilson Hall. The small, decorative torrents at the corners of the porte cochère are now missing but will be restored as part of an extensive restoration project now in progress. The Converse Auditorium and Carnegie Library are on the right of the scene.

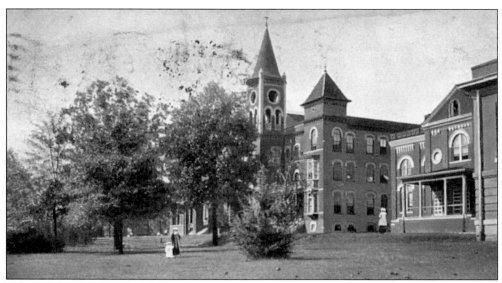

CONVERSE COLLEGE. (Raphael Tuck & Sons Post Card Series.) This scene from about 1905 shows Wilson Hall from the east. The corner of the Carnegie Library is at the extreme right. The building between the Library and Wilson Hall is the Converse Auditorium, with its original front. The Auditorium was formally opened in 1899 and was renamed for Albert Twichell in 1941. Twichell was a principal supporter of the South Atlantic States Music Festival held in the Auditorium.

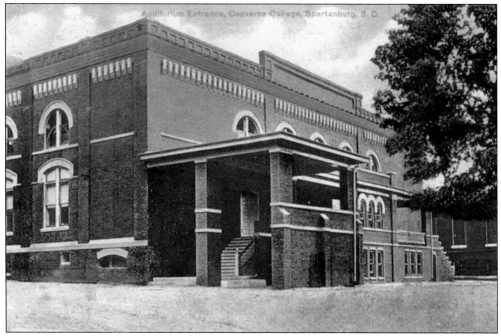

AUDITORIUM ENTRANCE, CONVERSE COLLEGE. (DuPré Book Store, Spartanburg, SC.) This card from 1910 shows the first alteration made to the entrance of the auditorium. A printed message on the back advertises the 16th annual South Atlantic States Music Festival for April 1910. (Card courtesy of the Regional Museum of Spartanburg County.)

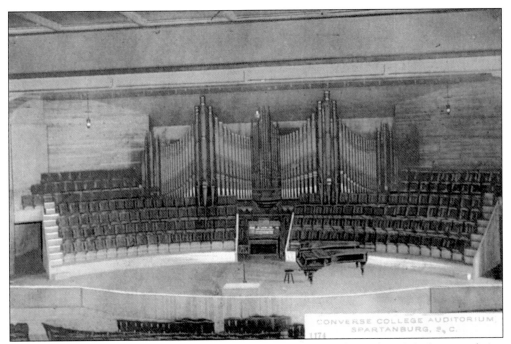

CONVERSE COLLEGE AUDITORIUM. (S.H. Kress & Co.) This card shows the original stage and pipe organ. The auditorium was known for its excellent acoustics. In the 1980s, Twichell Auditorium was rebuilt on the inside, and the porches on the front were enclosed with glass. The interior alterations retained the original quality of the acoustics.

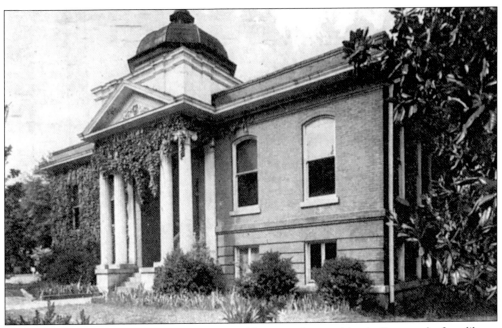

CARNEGIE LIBRARY, CONVERSE COLLEGE. (Copper plate etching.) Converse's first library building was dedicated in 1905. Previously the library had been in Wilson Hall. This card was mailed in 1912 by Mary Wilson Gee, longtime teacher and dean, to a former student.

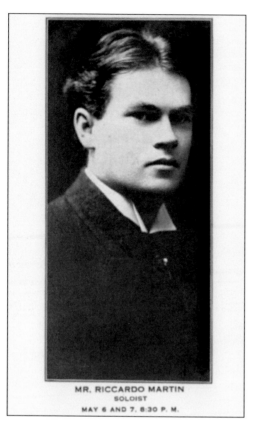

MR. RICCARDO MARTIN
SOLOIST
MAY 6 AND 7, 8:30 P. M.

SOUTH ATLANTIC STATES MUSIC FESTIVAL. The South Atlantic States Music Festival began in 1894 under the organization of Richard Henry Peters, the first director of the Converse College Music Department. For three days each spring, performers from all over the world transformed Spartanburg into a music Mecca. Postcards commemorating the artists were issued. This card was issued for the festival in 1914 and shows Riccardo Martin.

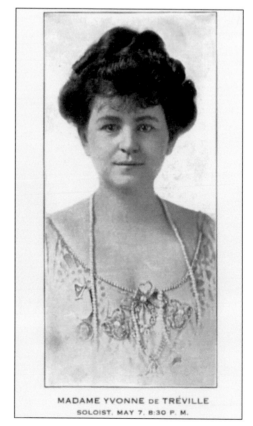

MADAME YVONNE DE TRÉVILLE
SOLOIST, MAY 7, 8:30 P. M.

SPARTANBURG MUSIC FESTIVAL. In 1914, the name of the festival was changed to the Spartanburg Music Festival. Performances were held in the Converse Auditorium. This is a card for the 1914 festival showing Madame Yvonne de Tréville. Due to the onset of the Great Depression, the last festival was held in 1930.

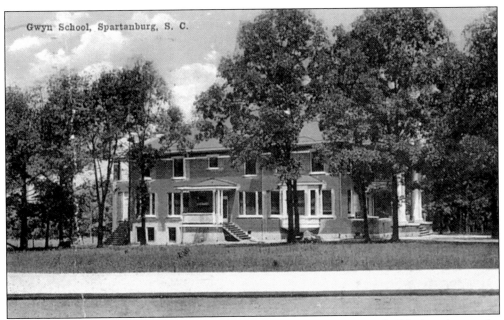

Gwyn School, Spartanburg, S. C.

THE GWYN SCHOOL. The Gwyn School was erected in 1914 on North Fairview Avenue by the three Gwyn sisters to prepare students for admission to Converse College. The school began with the encouragement and support of the college and served the same purpose as the Wofford Fitting School. The Gwyn School closed in 1920. Converse College purchased the building and transformed it into Cudd Dormitory.

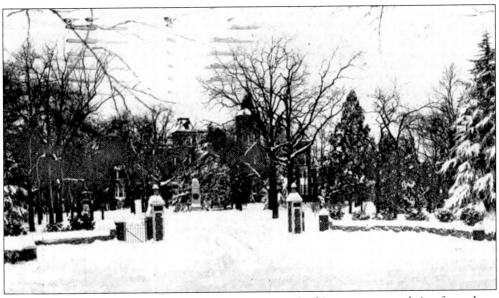

PELL GATES, CONVERSE COLLEGE. (Photoprint, *c.* 1940.) This snowy scene, dating from about 1940, shows Converse's main entrance, which had been named the Pell Gates after Robert P. Pell, who was president from 1902 to 1932. The gates were west of where the entrance is today. In the late 1950s, the main gate was aligned with Mills Avenue and an entrance circle was created. (Card courtesy of Tommy Acker.)

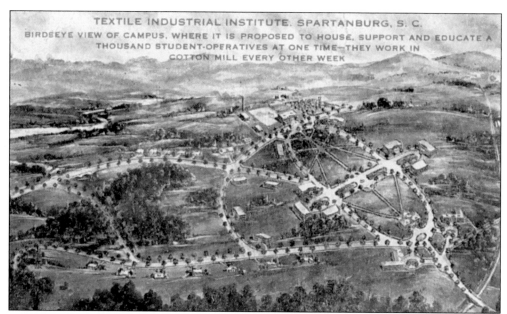

TEXTILE INDUSTRIAL INSTITUTE. The Textile Industrial Institute was the dream of Methodist minister David E. Camak. He wanted to establish a college in which students could alternately work in a mill one week and attend classes the next week. The idea was opposed by the Methodist bishop but supported by Walter S. Montgomery (1866–1929), president of Spartan Mills. The school opened in 1911 in a house in Spartan Mill Village.

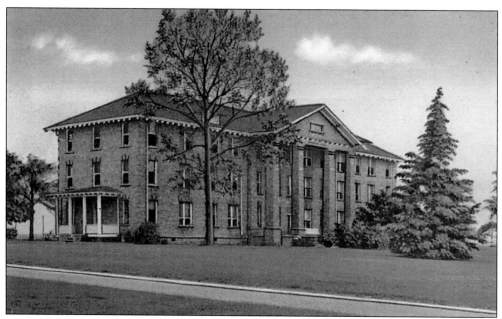

HAMMOND HALL, SPARTANBURG JUNIOR COLLEGE. (City News Agency, Spartanburg, SC.) The Textile Institute moved to its present campus in 1914 with the completion of the first building, Hammond Hall. Charles P. Hammond was president of Hammond, Brown, Wall Furniture Company and a benefactor of the school. The school later renamed itself Spartanburg Junior College and is now known as Spartanburg Methodist College.

Five

TEXTILE MILLS AND COTTON

After the War of 1812, New England textile mills went into a slump. This caused some New England operators to relocate southward. Proximity to the raw material, cheaper labor, and lower taxes and property costs gave the Southeast an advantage over New England. Michael Schenck, of Swiss-German origins, appears to have built the first mill in the Southeast in 1815 near Lincolnton, North Carolina. The first mills in Spartanburg County were established soon afterward near Cross Anchor by New Englanders. One of these lasted only a few years. The other closed after the Civil War. More important to Spartanburg County was the Lincolnton operation. It attracted men who later moved on to Spartanburg County and became the founders of the area's modern textile industry. James Bivings, Vardry McBee, and Dexter Edgar Converse all passed through Lincolnton. Spartanburg County's rivers and creeks provided waterpower that led these men to envision the development of Spartanburg into a cotton-manufacturing center.

About 1832, James Bivings purchased land along Lawson's Fork Creek and built the Bivingsville Cotton Factory. It was the first enduring textile operation in the area. In 1870 the Bivingsville mill was sold to Edgar Converse. He and the other entrepreneurs, referred to in this chapter, realized the vision of Spartanburg as a textile center.

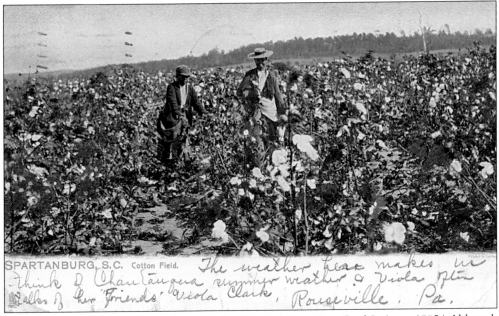

COTTON FIELD, SPARTANBURG, SC. (Raphael Tuck & Sons Post Card Series, *c.* 1905.) Although several inventions existed for picking cotton, most cotton was still hand picked. These men and women, or "pickers," were paid from 30 to 50¢ a hundredweight.

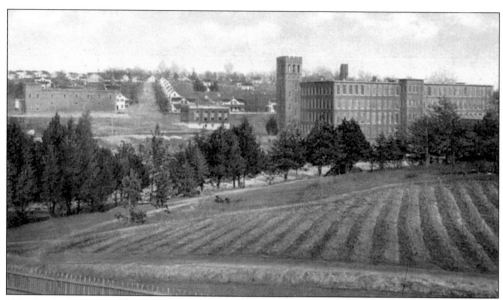

GLENDALE COTTON MILLS. (International Post Card Co., New York, printed in Germany.) After acquiring ownership of the Bivingsville Mill, Edgar Converse enlarged the plant. When he married his 17-year-old first cousin, Helen Twichell, she changed the name of Bivingsville to Glendale. The main street of the village, lined by white cottages, was called Broadway. The company store stands at the beginning of the street. The mill is now closed.

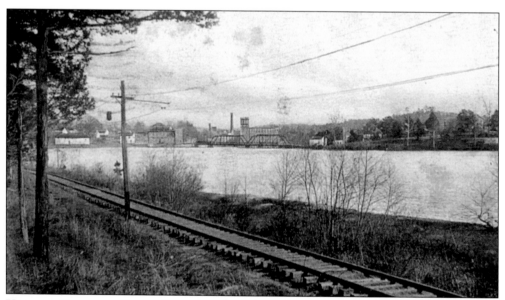

VIEW IN GLENDALE PARK, SHOWING GLENDALE COTTON MILLS. (American News Co., New York.) The park, which included a pavilion and a pond covering a large area above the mill dam, was a pleasant spot for picnics. Streetcar tracks are visible in the foreground. The streetcar came out Pine Street to Country Club Road and on to Glendale. At the beginning of the twentieth century, the standard work week for mill operatives was 66 hours—an outing was welcomed.

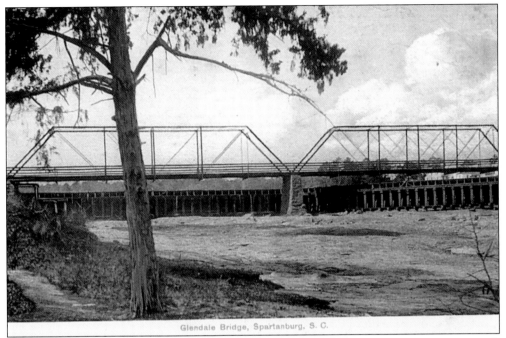

GLENDALE BRIDGE. (The American News Co., New York.) This iron bridge over Lawson's Fork Creek was used as a walkway after the construction of a new bridge in 1977. (Card courtesy of Gayle and Danny Russell.)

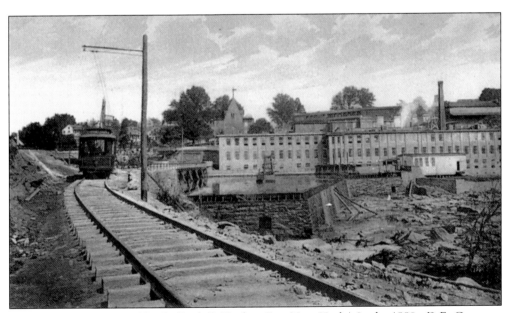

CLIFTON COTTON MILL NO.1. (Paul C. Koeber Co., New York.) In the 1880s, D.E. Converse & Company bought property on the Pacolet River and expanded beyond the mill at Glendale. In 1881, the first mill of Clifton Manufacturing Company was opened. In 1889, Clifton Mill No. 2 began operation about three-fourths of a mile below No. 1. (Card courtesy of the Regional Museum of Spartanburg County.)

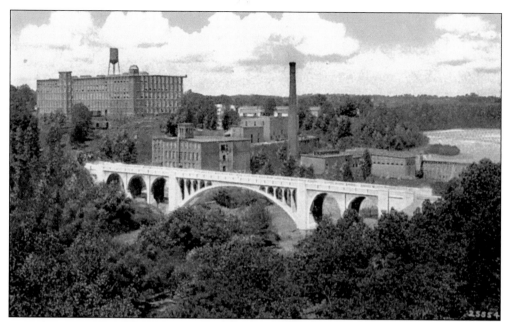

CONVERSE COTTON MILLS, CONVERSE, SC. (Asheville Post Card Co.) In 1895, Clifton Mill No. 3 opened about a mile above Mill No. 1 at what came to be known as Converse, South Carolina. This building was almost completely destroyed by the flood of 1903. The building, shown in this card, was constructed in 1904 on a hill slightly above the Pacolet River.

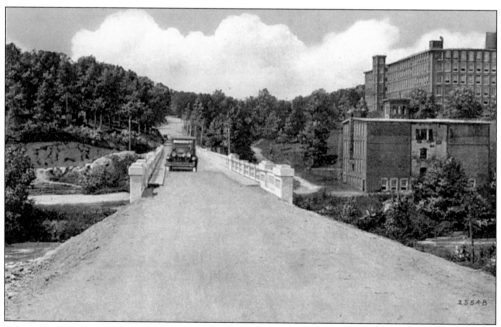

NATIONAL ROAD SHOWING PACOLET RIVER BRIDGE AND CONVERSE COTTON MILL. (Asheville Post Card Co.) The road that became Highway 29 crossed the Pacolet River beside Clifton Mill No. 3. This mill was the last of the Clifton Manufacturing Company plants to close. After being sold to Dan River Mills, it ceased operation early in 1972. (Card courtesy of Graham Bramlett.)

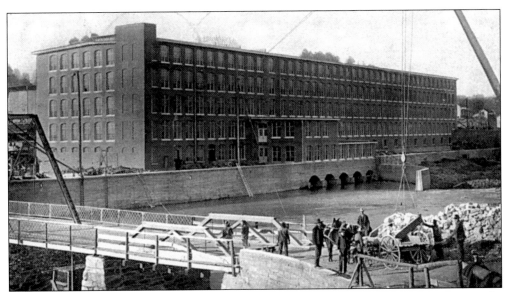

PACOLET COTTON MILLS. (International Post Card Co., New York, printed in Germany.) Pacolet Manufacturing Company, of which John H. Montgomery was a principal partner, was founded in 1882 and soon afterwards began construction of Plant No. 1 at Trough Shoals on the Pacolet River. The flood of 1903 badly damaged the mills on the Pacolet River. Pacolet Manufacturing Company is no longer in operation. The mills have been dismantled, but the town of Pacolet Mills still retains its identity and its pride.

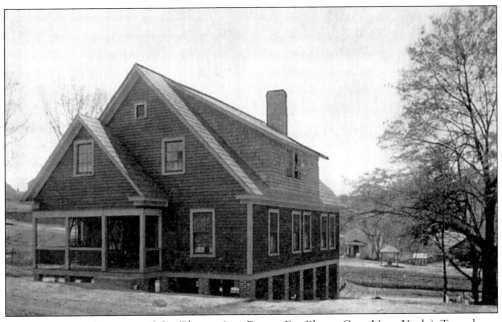

A COTTAGE IN TROUGH, SC. (Photoprint, Ess an Ess Photo Co., New York.) Trough, or Trough Shoals, was an earlier name for the town of Pacolet Mills. This cottage is still standing on Montgomery Street, up the hill from where the day nursery once operated.

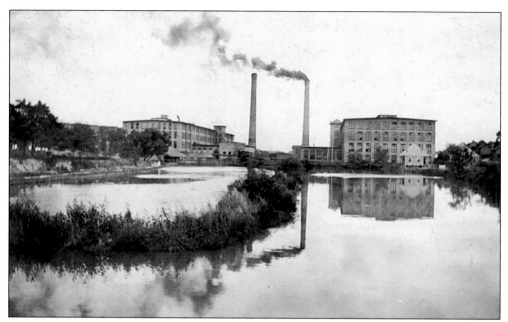

SPARTAN MILLS. (Photoprint, *c.* 1900.) In 1888, the Spartanburg Manufacturing Company was organized with John H. Montgomery as president. At the intersection of Howard and College Streets, Spartan Mill No. 1 (shown on the left) began producing yarn in 1890 and was the first mill in the city limits. The mill machinery was powered by boilers, which were supplied with water from the lake beside the mill. (Card courtesy of the Regional Museum of Spartanburg County.)

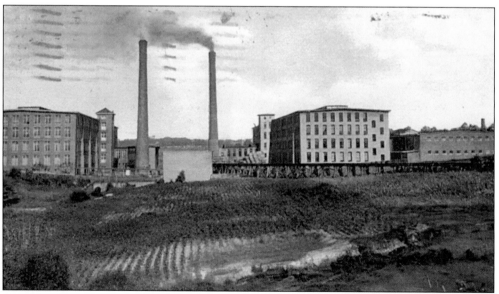

SPARTAN MILLS. (International Post Card Co., New York, printed in Germany.) In this card, Mill No. 1 is on the right. In 1896, Spartan Mill No. 2 (on the left) was built beside the first mill, of which it was almost a twin. Mill No. 2 produced broadcloth. The smokestacks, at 178 feet, were the highest in the South. The railroad tracks on the right brought cotton right up to the mill.

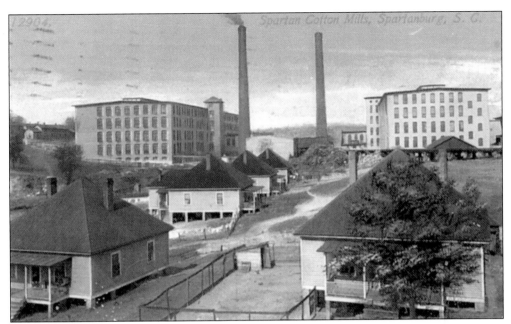

SPARTAN COTTON MILLS. (The Acmegraph Co., Chicago.) This card, postmarked 1917, shows the area behind the mills to now be the site of an expanding mill village. When the mill was established in 1890, a mill village of 150 four-room cottages was built. A fire in 1907 destroyed 70 of the cottages in Montgomeryville. (Card courtesy of Gayle and Danny Russell.)

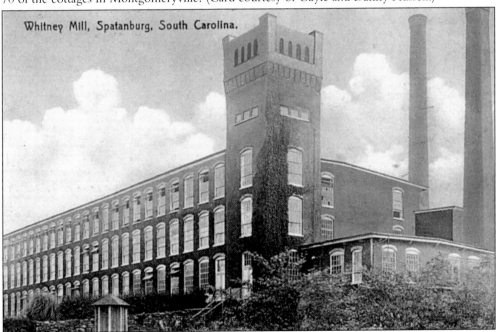

WHITNEY MILL. (The Rotograph Co., New York, printed in Germany.) Named for Eli Whitney and designed by Lockwood-Green, Whitney Mill opened as a division of Pacolet Manufacturing Company in 1880. Victor Montgomery succeeded his father, John H. Montgomery, as president. After passing out of the Montgomery family for several years, Whitney was bought by Spartan Mills in 1964. The mill closed in 1996. (Card courtesy of Graham Bramlett.)

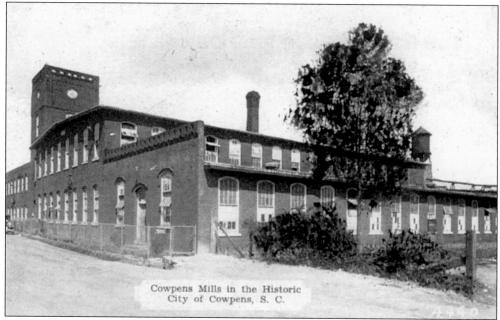

Cowpens Mills in the Historic
City of Cowpens, S. C.

COWPENS MILLS. (The Acmegraph Co., Chicago.) Cowpens Manufacturing Company was organized in 1889 by R.R. Brown and other investors. Farmers would bring cotton to the mill where it would be ginned, combed, woven, and shipped from the same premises. The mill closed during the Depression. Several attempts to reopen it after World War II were short lived. The mill burned in March 1999. Only the outer walls remain today. (Card courtesy of Steve Cromer).

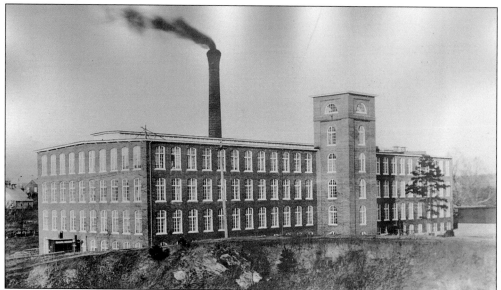

ARKWRIGHT MILLS. (Photograph, *c.* 1905.) In 1898, the first plant of Arkwright Mills went into operation. Organized by Robert Z. Cates Sr., the mill was named for Richard Arkwright, the inventor of textile machinery during the Industrial Revolution in Britain. Arkwright Mills is still in operation. The 1898 plant is no longer standing. (Photograph courtesy of Dexter Cleveland.)

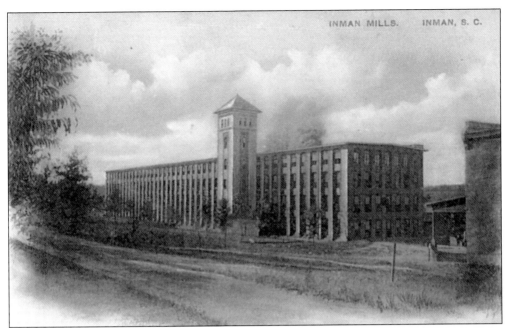

INMAN MILLS. (Inman Drug Co., postmarked 1914.) Inman Mills was established 20 miles north of Spartanburg by James A. Chapman in 1902. Chapman was a Spartanburg native who practiced law in New York City for several years before returning to Spartanburg to take advantage of opportunities in the textile industry. The mill is still in operation under the Chapman family.

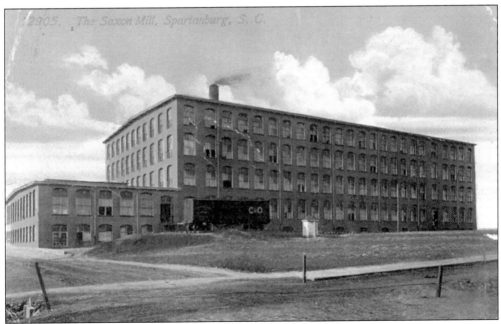

THE SAXON MILL. (The Acmegraph Co., Chicago.) Saxon Mills was organized in 1902 under the leadership of John A. Law, a Spartanburg banker. In 1945, it was sold to Reeves Brothers and then, in 1964, to Phillips Fibers Company. Today Amoco Fibers operates a rebuilt plant on the site. (Card courtesy of Steve Cromer.)

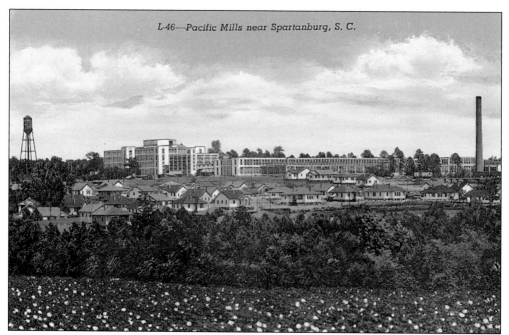

PACIFIC MILLS. (City News Agency, Spartanburg, SC.) In 1923, Pacific Mills in Massachusetts announced plans to build a plant near Spartanburg at an area known as Groce. This scene shows the model village of cottages built for the workers. The area was renamed Lyman after an earlier president of Pacific Mills. The mill's proximity to the raw material can be seen in the foreground.

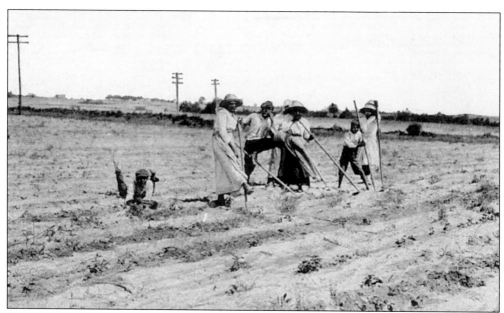

HOEING COTTON IN SPARTANBURG COUNTY, SC. (Ligon's Drug Store, Spartanburg, SC.) An average day's work for a picker was considered to be 200 to 300 pounds of cotton. The season lasted about three months, and a field was picked once every two or three weeks.

SPARTANBURG, SC, A COTTON FIELD COVERED WITH SNOW. (Photoprint, 1918.) The winter of 1917–1918 was especially severe, which accounts for this unusual picture of a cotton field covered with snow. This card, which is postmarked February 1918, was mailed from Camp Wadsworth. The message written on the back states the following: "This is the sunny South." (Card courtesy of Tommy Acker.)

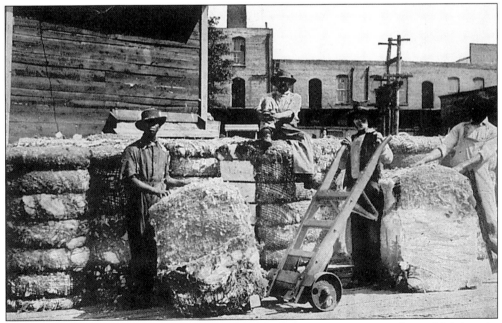

COTTON READY FOR SHIPMENT. (Photoprint, Ligon's Drug Store, Spartanburg, SC.) In spite of the caption on this card, the scene probably shows cotton being unloaded beside a mill. Many of those who picked the cotton and worked at the warehouses were former slaves or descendants of slaves.

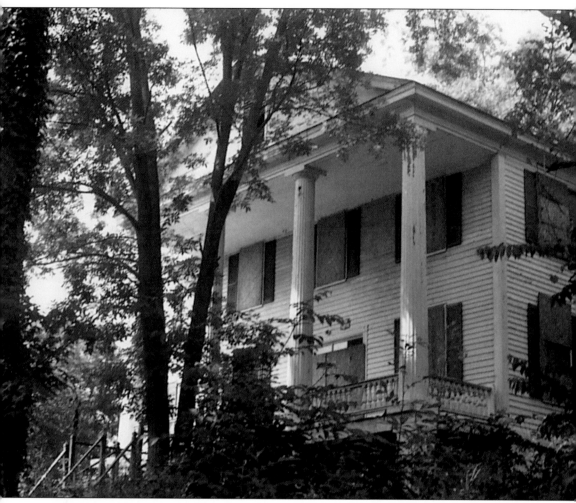

THE BIVINGS / CONVERSE HOUSE AT GLENDALE. (Photograph.) About 1835, James Bivings built this antebellum house on a hill overlooking his new Bivingsville Cotton Factory. The house has porticoes on both the front and back and a wide hall that runs through the house. After Dexter Edgar Converse acquired ownership of the mill, he and his wife, Helen Twichell Converse, occupied the house and built an addition on the side. When, after 19 years of marriage, a daughter was born, the Converses moved to a new residence on Pine Street in Spartanburg. The house, one of Spartanburg County's oldest, is still standing.

Six

RESORTS, PARKS, AND ENVIRONS

This chapter is something of a catchall. It includes scenes from Spartanburg County's oldest resort at Glenn Springs; early-twentieth-century pleasure parks, such as Garrett Springs and Rock Cliff Park; and more recent swimming holes at Rainbow Lake and Cleveland Park. There are scenes of one of the city's most pervasive waterways, Lawson's Fork Creek, and of pre-textile-era mills, represented by Anderson's Mill and White's Mill. There are very few cards of the smaller communities in the county. This chapter includes a small number of postcards of Cowpens, Landrum, and Woodruff. Novelty cards were popular during the early part of the twentieth century but are rare for Spartanburg. Two are placed at the end of the chapter.

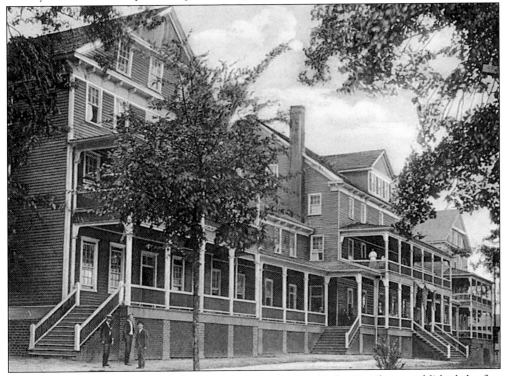

GLENN SPRINGS HOTEL. (Paul C. Koeber Co., New York.) John B. Glenn established the first resort at Glenn Springs. Maurice Moore and other investors built the hotel, which was sold to John Conrad Zimmerman in 1845. The hotel became one of the state's most fashionable resorts prior to the Civil War. Open from June 1 to October 1, the hotel hosted many visitors from the Lowcountry, who were frequent during the summer months. Tragically, the structure burned in 1941.

BOTTLING HOUSE, GLENN SPRINGS. (Photoprint, *c.* 1900.) The resort at Glenn Springs developed around a mineral spring. Visitors to the hotel "took the cure," and the spring water was also bottled and sold locally and nationally. These buildings were part of the bottling process.

OLD MILL NEAR SPARTANBURG. (E.C. Kropp, Milwaukee.) Formerly known as Foster's Mill, this mill was acquired by James (Tyger Jim) Anderson in 1831. It is located on the North Tyger River on what is now Anderson's Mill Road. The county justices held the first court sessions in the mill in June 1785. The original mill was destroyed by the flood of 1903. The present structure was built on the foundations in the early twentieth century.

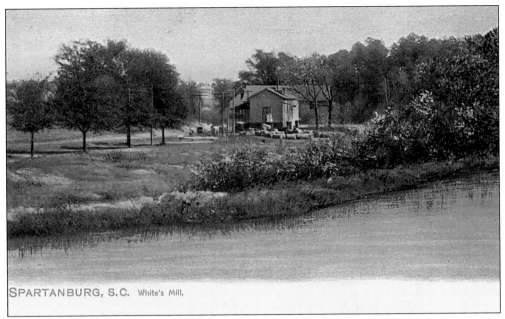

SPARTANBURG, S.C. White's Mill.

WHITE'S MILL. (Raphael Tuck & Sons Post Card Series.) A grist- and sawmill was located on this site in the late eighteenth century and was known as McKie's Mill after Alexander McKie. The White family acquired the property in 1863. A clubhouse for a nearby development is located on the foundations of the old mill today. Lawson's Fork Creek is seen in the foreground.

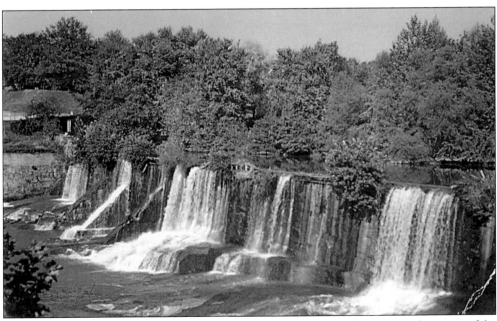

SPILLWAY ON LAWSON'S FORK CREEK. (City News Agency, Spartanburg, SC.) The origin of the creek's name is not known. It appears under the name "Lawson's Fork" on the earliest map of South Carolina and on Robert Mills's 1825 map of Spartanburg County. The falls in this scene is beside Whitney Mill and shows the waterway to be more a river than a creek.

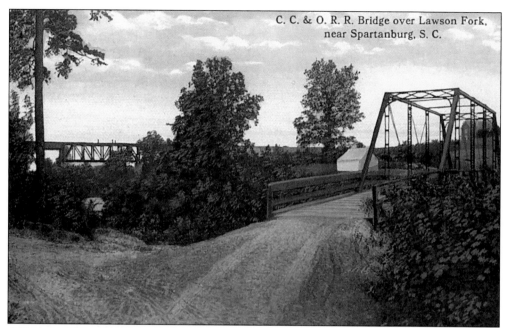

C. C. & O. R. R. Bridge over Lawson Fork,
near Spartanburg, S. C.

C.C. & O.R.R. Bridge over Lawson's Fork. (S.H. Kress & Co.) The Carolina, Clinchfield & Ohio Railroad Bridge is visible in the background. The bridge and road on the right are along Heywood Avenue near White's Mill.

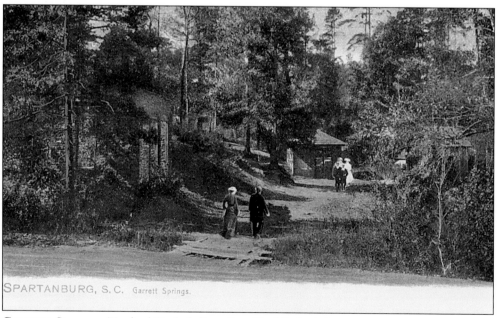

SPARTANBURG, S.C. Garrett Springs.

Garrett Springs. (Raphael Tuck & Sons Post Card Series.) Garrett Springs was established in the late nineteenth century as a recreational park. Located on Lawson's Fork Creek, it was off of what is now Heywood Avenue opposite White's Mill.

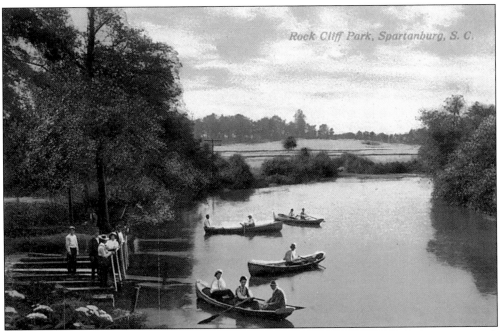

ROCK CLIFF PARK. In 1906, James T. Harris purchased Garrett Springs and renamed it Rock Cliff Park. A plant was built for bottling the spring water and high-quality ginger ale. Plans for the construction of a large resort hotel were never carried out; however, a park of several acres was laid out for all forms of outdoor amusements, including boating on Lawson's Fork Creek.

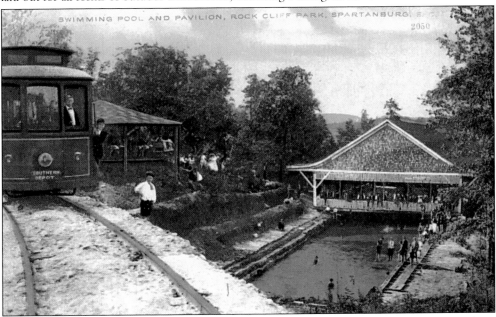

SWIMMING POOL AND PAVILION, ROCK CLIFF PARK. (S.H. Kress & Co.) James Harris built a large pavilion with a stage where vaudeville shows could be put on in the summer. The swimming pool was supplied by several springs, which provided a constant supply of fresh water. An extension of the trolley car line was run from the existing terminal on East Main Street directly to the pavilion. Rock Cliff Park closed during the Depression.

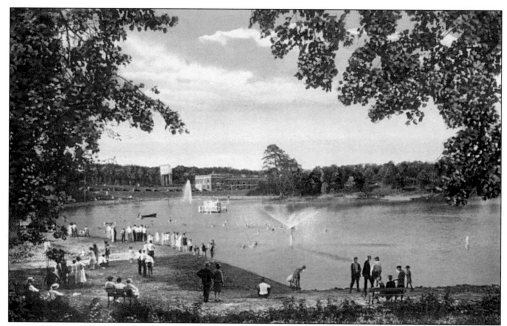

RAINBOW LAKE. (E.C. Kropp Co., Milwaukee.) Rainbow Lake was built as a WPA project. Located northeast of Boiling Springs, it was owned by the Spartanburg Water Works and open to the public for picnicking and swimming. Known first as Crescent Lake, the name was changed because rainbows would often appear as the sun struck the spray from the fountain in the center of the lake. The building across the lake is the Treatment Plant for the water system.

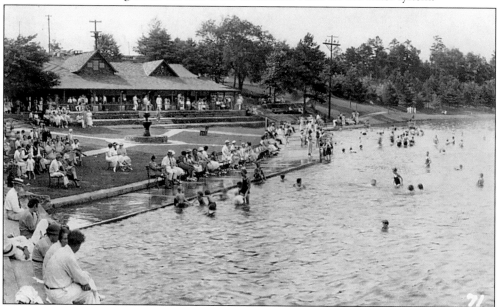

RAINBOW LAKE, RECREATION CENTER. (Photoprint, *c.* 1940.) Among the facilities available were a diving platform, two concrete piers for sunbathing, a bathhouse, a picnic area, and a playground. The lake was closed in 1967 and drained in order to install a water line across it. The park is still open for picnicking. The Treatment Plant is still in operation. (Card courtesy of Graham Bramlett.)

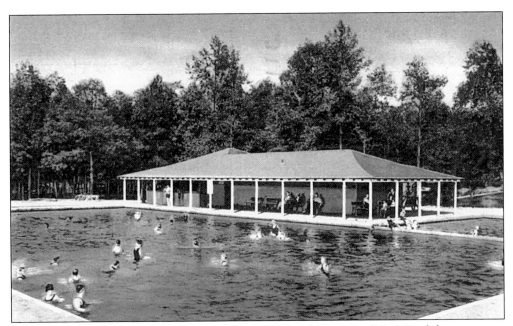

MUNICIPAL SWIMMING POOL, CLEVELAND PARK. (Asheville Post Card Co.) Land that was a part of John B. Cleveland's Bonhaven estate was given to the City as a public park in 1923. The City built a public swimming pool on the property. The pool is no longer in operation. (Card courtesy of Tommy Acker.)

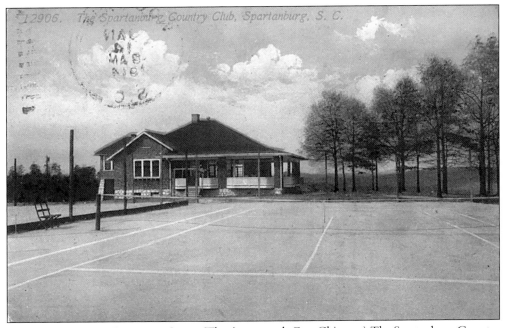

THE SPARTANBURG COUNTRY CLUB. (The Acmegraph Co., Chicago.) The Spartanburg Country Club was established in 1910. This card, postmarked 1914, shows the first clubhouse. In addition to the golf course, the main attraction offered to members at the time was the tennis courts shown in the foreground. (Card courtesy of Bill Littlejohn.)

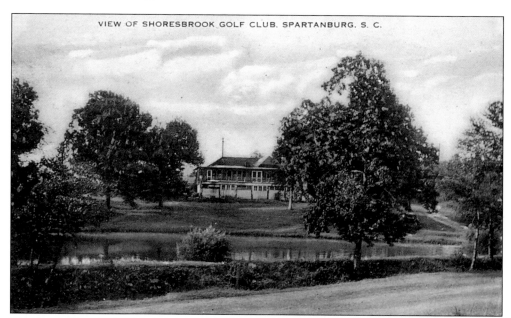

VIEW OF SHORESBROOK GOLF CLUB. (Artvue Post Card Co., New York.) During the First World War, the city engineer, J.H. Shores, donated his farm as a location for portable houses to be used by Camp Wadsworth troops and their families. After the war, the land was used for a golf club. Today the Shoreswood subdivision occupies the site. (Card courtesy of Graham Bramlett.)

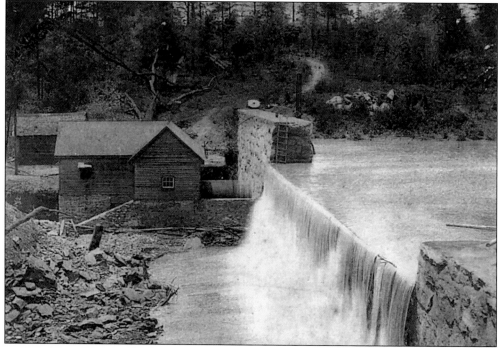

AN ELECTRIC POWER PLANT, NEAR SPARTANBURG, SC. (Paul C. Koeber Co., New York.) This card, postmarked 1908, shows how the area's waterways could be harnessed to produce electric power. (Card courtesy of the Regional Museum of Spartanburg County.)

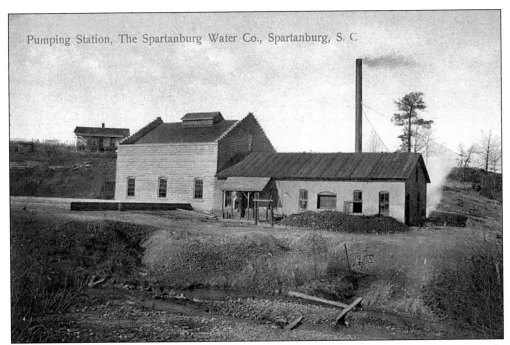

PUMPING STATION, THE SPARTANBURG WATER CO. (International Post Card Co., New York, printed in Germany.) Several pumping stations, like the one shown in this early-twentieth-century card, were located between the reservoir and town to boost the flow of water.

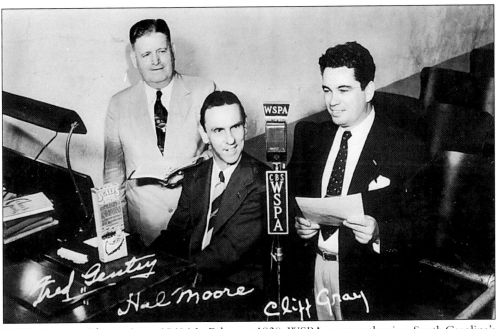

WSPA RADIO. (Photoprint, *c.* 1940.) In February 1930, WSPA went on the air as South Carolina's first commercial radio station. Its first studios were on the top floor of the Montgomery Building. This picture is probably from the 1940s. Cliff Gray, on the right, was known as "Farmer" Gray. (Card courtesy of Tommy Acker.)

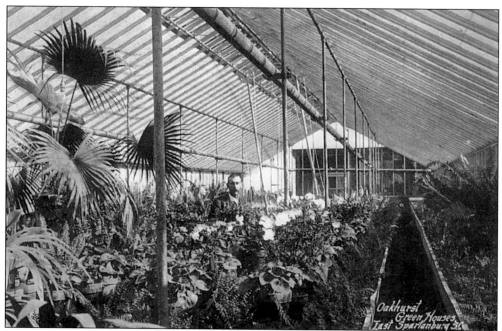

OAKHURST GREEN HOUSES, EAST SPARTANBURG. (Postmarked 1912.) Located on the Glendale Car Line, near the current intersection of South Pine Street and Country Club Road, Oakhurst Green Houses specialized in cut flowers and decorative bedding plants. The proprietor, Dr. R. Lewis Branyon, also operated the Spartanburg Dental Rooms on Main Street.

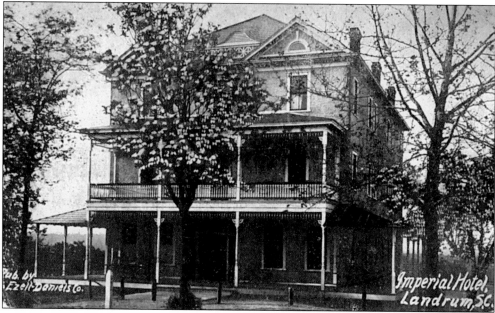

IMPERIAL HOTEL, LANDRUM, SC. It was probably soon after the railroad was built through the area in 1877 that the Imperial Hotel opened on the corner of North Shamrock and Durant Streets, adjacent to the train station. The proprietors were Mr. and Mrs. A.M. Foster. When the hotel closed after their deaths, a house was built on the same lot from the lumber. Today the site is occupied by the Landrum Fire Department. (Card courtesy of Bill Littlejohn.)

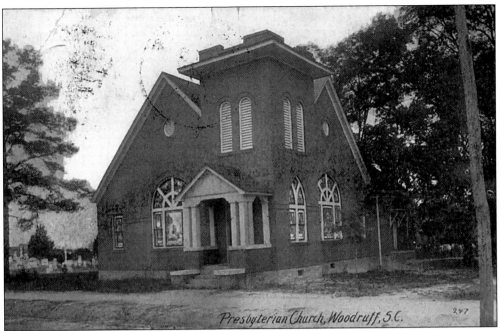

PRESBYTERIAN CHURCH, WOODRUFF, SC. The First Presbyterian Church was organized in 1877 and constructed a wooden building on the corner of West Hayne and Academy Streets. In 1911, the congregation built their second church, shown in this card, on West Georgia Street. After constructing their third and present building in 1952, First Presbyterian sold the 1911 church to the Associate Reform Presbyterian congregation in 1953. (Card courtesy of Scott Godfrey.)

SALEM METHODIST CHURCH, COWPENS, SC. (Photoprint, Merrimack Post Card Co, Hoverhill, MA.) Salem Methodist Church was admitted to the South Carolina Methodist Conference in 1885. It now occupies the oldest church building in Cowpens. The sanctuary has an oak-beam ceiling. (Card courtesy of George Mullinax.)

THERE'S ROOM FOR ANOTHER ONE
IN SPARTANBURG, S. C.

HOW ABOUT YOU?

There's Room for Another One in Spartanburg, SC. (Holmfirth Bamforth Publishers, England and New York, *c.* 1910.) Novelty cards, such as the two on this page, were popular at the turn of the century. Published by an English company, they were probably mass produced for a "fill-in-the-town-name" market. (Card courtesy of Bill Littlejohn.)

I'D LIKE TO RENEW YOUR
ACQUAINTANCE
IN SPARTANBURG. S. C.

I'd Like to Renew Your Acquaintance in Spartanburg, SC. (Holmfirth Bamforth Publishers, England and New York, *c.* 1910.) Both of these novelty cards were a part of the English publisher's "Local Lovers Series." There was barely room to fill in "Spartanburg" at the top of this one. (Card courtesy of Bill Littlejohn.)

Seven

MILITARY CAMPS

Spartanburg benefitted during both World Wars by being chosen as the location of army training camps. Not only was money injected into the local economy, but the interchange between the town and young men from other parts of the United States had, in some degree, a social impact upon the city. When the United States declared war upon Germany and its allies in April 1917, many communities were anxious to have training camps located nearby. This was certainly the dream of leaders in Spartanburg, such as Mayor John F. Floyd, Chamber of Commerce President Ben Hill Brown, and local business leader Frank McGee. Spartanburg had an advantage in that the Reverend W.H.K. Pendleton, rector of the Episcopal Church of the Advent, had taught Secretary of War Newton W. Baker at Episcopal High School in Virginia. Spartanburg got Camp Wadsworth.

During 1940, as the United States moved closer to involvement in World War II, Spartanburg again had advantages in its quest to be chosen as the site of a training camp. One such advantage was James F. Byrnes's influence in Washington. In addition, the area's weather made possible year-round training. After months of construction, Camp Croft opened in February 1941.

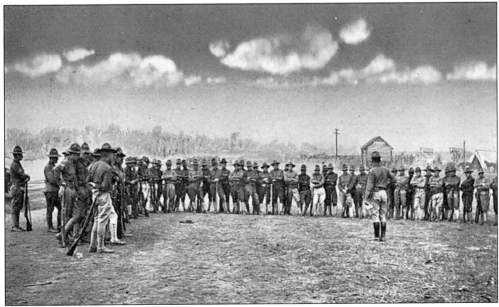

LECTURING TO THE SOLDIERS ON THE DRILL GROUND, CAMP WADSWORTH. (Photoprint, George Dearman Co., Spartanburg, SC.) The camp was named in honor of Brigadier General James S. Wadsworth, a Union commander during the Civil War. He led troops at the Battles of Fredericksburg and Gettysburg and was killed during the Wilderness Campaign in Virginia.

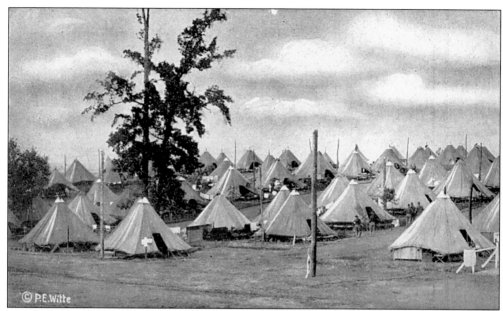

CAMP SCENE, CAMP WADSWORTH. (Photoprint, P.E. Witte.) The camp was located 3 miles west of Spartanburg along both sides of what is today Highway 29. There was not time to construct barracks. The troops were housed in tents, many of which had dirt floors to begin with. The camp was laid out in rectangles of 416 tents each. Plots of land 1,000 by 750 feet were allocated for each regiment.

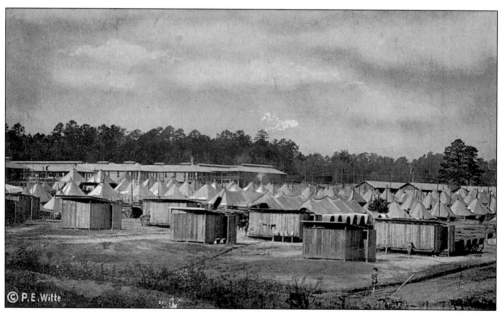

CAMP SCENE, CAMP WADSWORTH. (Photoprint, P.E. Witte.) Proper latrines were not provided for the tent cities. Wooden privies and bathhouses, shown in the foreground of this card, were the only facilities provided. Little remains of the camp today, except some pavement and a couple of concrete bunkers. The camp was situated all around the area of today's Westgate Mall.

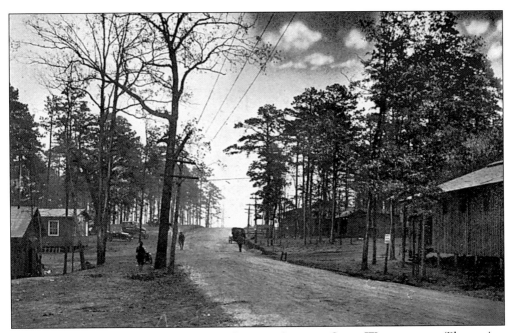

TIMES SQUARE, BROADWAY AND FORTY-SECOND STREET, CAMP WADSWORTH. (Photoprint, Army YMCA, Camp Wadsworth.) Many of the troops who trained at Camp Wadsworth were members of New York State National Guard units. Thus, some of the roads at the camp were named after New York streets. (Card courtesy of Graham Bramlett.)

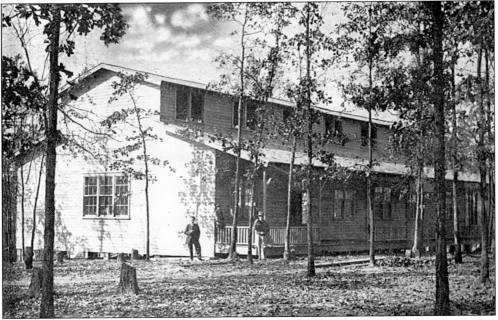

KNIGHTS OF COLUMBUS HALL, CAMP WADSWORTH. (Photoprint, Army YMCA, Camp Wadsworth.) Almost 1,000 wooden buildings were constructed, providing a boom for area contractors and boosting employment. Local religious groups constructed buildings to provide for the spiritual needs of young men about to be sent to the Western Front.

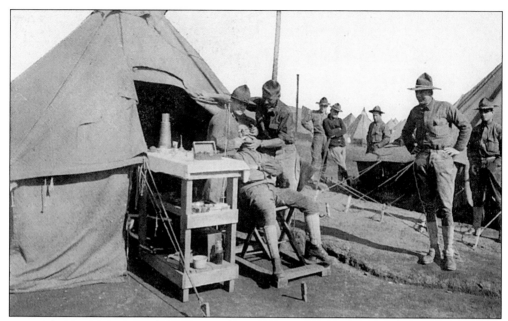

Camp Dentist, Camp Wadsworth. (Photoprint, Ligon's Drug Store, Spartanburg, SC.) Wadsworth was like a city unto itself, with a hospital unit of 65 buildings. The dentist in this card is relegated to operating out of a tent.

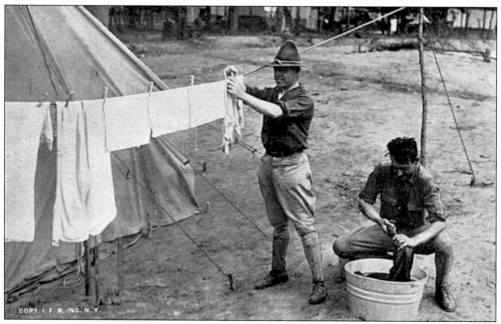

We Have Wash Days Too at Camp Wadsworth. (Photoprint, George Dearman, Spartanburg, SC.) The soldiers had to do much of their own washing. The message on the back of this card states the following: "We do our washing in the rear of the bath houses." Large loads of washing from the hospital units had to be sent off base, sometimes to laundries in Asheville, North Carolina.

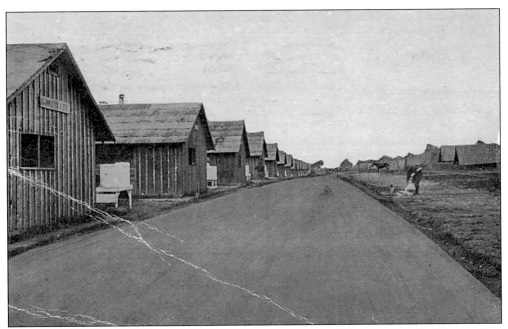

STREET VIEW SHOWING MESS SHACKS, CAMP WADSWORTH. (Photoprint, A.M. Simon, New York.) Waste from the camp mess halls was given to local farmers to feed their livestock. Manure from the camp stables was used by the farmers to fertilize their fields.

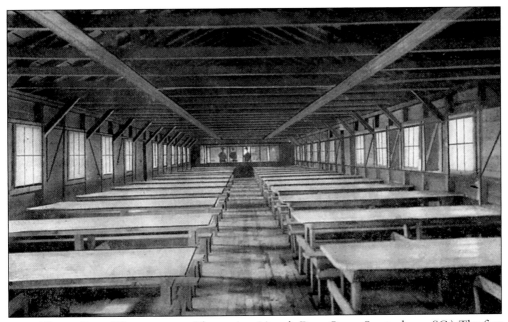

MESS HALL, CAMP WADSWORTH. (Photoprint, Ligon's Drug Store, Spartanburg, SC.) The first troops arrived in September 1917. In November, they consumed over 33,000 pounds of turkey for their Thanksgiving dinner.

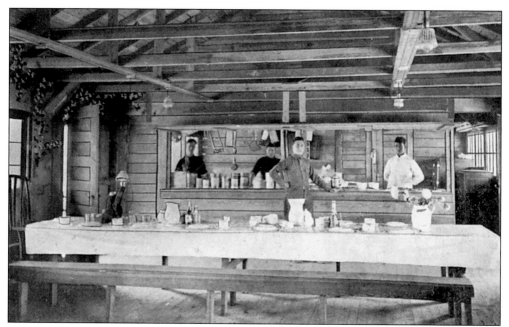

OFFICERS' DINING HALL AND KITCHEN, CAMP WADSWORTH. (Photoprint, Ligon's Drug Store, Spartanburg, SC.) Officers eat separately from enlisted men. They merited a tablecloth on their serving table.

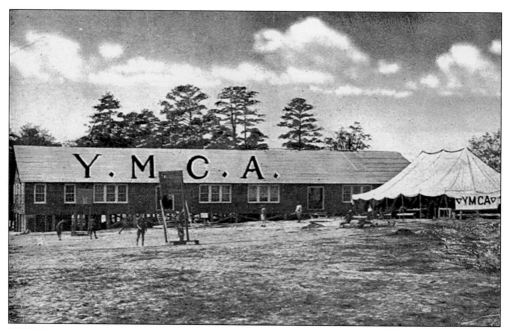

YMCA, THE SOLDIER'S HOME AWAY FROM HOME, CAMP WADSWORTH. (Photoprint, Army YMCA.) Six large YMCA buildings at the camp provided recreational and leisure activities for the troops. The Army YMCA published a camp newspaper, the *Gas Attack*, which contained news and stories.

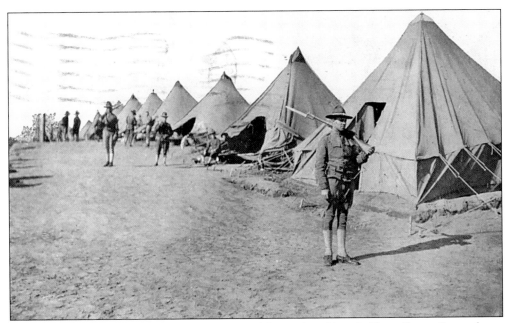

THE "GUARDHOUSE," CAMP WADSWORTH. (Photoprint, Ligon's Drug Store, Spartanburg, SC.) Perhaps the inmates of the Guardhouse had taken firewood from the kitchen supply. Troops frequently complained about the shortage of firewood to keep warm. (Card courtesy of Tommy Acker.)

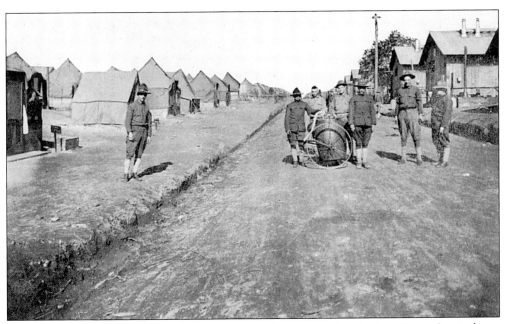

A DISINFECTING SQUAD, CAMP WADSWORTH. (Photoprint, Ligon's Drug Store, Spartanburg, SC.) With such a concentration of individuals, the spread of disease was a danger. Spanish influenza hit the camp in September 1918. In the long run, more troops died of pneumonia than died from flu.

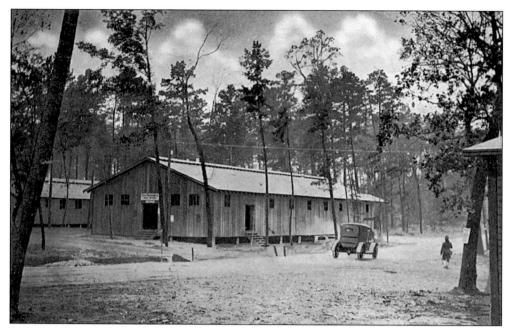

U.S. POST OFFICE, CAMP WADSWORTH. (Photoprint, George Dearman Co., Spartanburg, SC.) At the height of the camp's activity, there were 30,000 troops at Wadsworth. The large volume of mail was processed at several post office buildings.

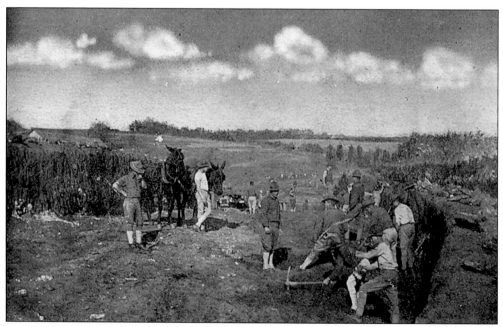

VANDERBILT HIGHWAY OR SNAKE ROAD, BUILT BY OUR SOLDIERS, CAMP WADSWORTH. (Photoprint, Army YMCA.) The 22nd New York Engineers, commanded by Colonel Cornelius Vanderbilt, was given the task of improving one of the inadequate roads connecting town and camp. This road was widened and several short bridges constructed.

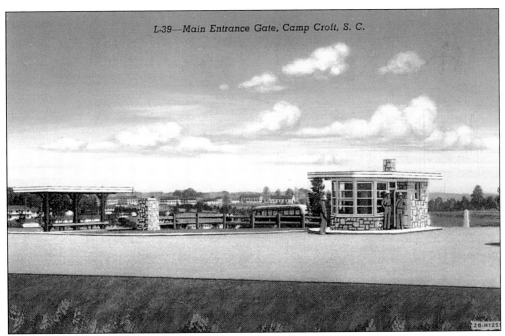

L-39—Main Entrance Gate, Camp Croft, S. C.

MAIN ENTRANCE GATE, CAMP CROFT. (City News Agency, Spartanburg, SC.) The new Infantry Replacement Training Center was named for Greenville-born Major General Edward Croft. After graduating from The Citadel, he had a 40-year army career extending from the Spanish-American War to World War I and ending as the Army's chief of infantry.

MAIN POST EXCHANGE, CAMP CROFT. (Photoprint.) In addition to the Main Exchange, there were branch exchanges in each regimental area. Each stocked cigarettes, toiletries, stationary, and other common items needed by the troops. The Tailor and Cleaning Shops were concessions of the Post Exchange.

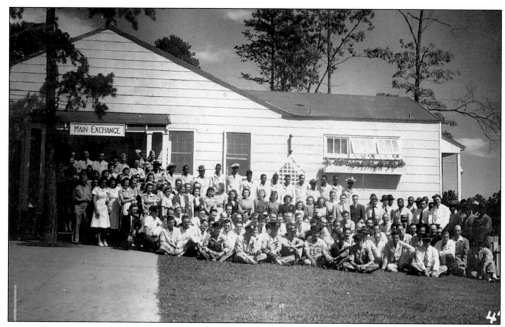

EMPLOYEES, POST EXCHANGE, CAMP CROFT. (Photoprint.) The Post Exchange acted as a cooperative. Profits were used to provide recreational and athletic equipment for the troops.

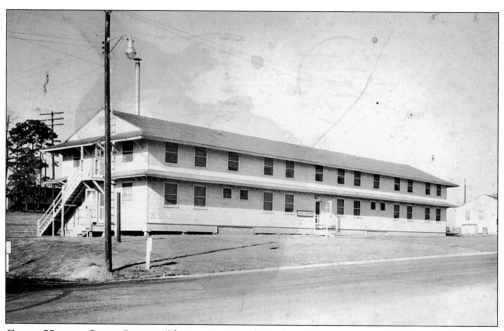

GUEST HOUSE, CAMP CROFT. (Photoprint.) Facilities for visitors were provided on the base. The Guest House was located on Headquarters Hill. Soldiers' visitors paid 50¢ a night. Altogether, Camp Croft covered an area of 3,000 acres, amounting to a city half the size of Spartanburg at the time.

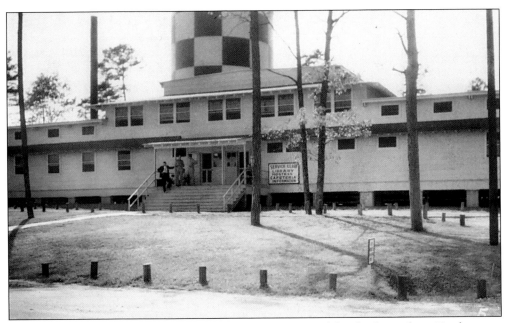

Service Club, Camp Croft. (Photoprint.) The Service Club, also located on Headquarters Hill, contained a library, cafeteria, information office, and hostess office. This was the enlisted men's service club.

30th Infantry Training Battalion, Camp Croft. (Photoprint.) The first troops arrived at Camp Croft on February 12, 1941, to serve as a training cadre. Soon afterwards, large numbers of enlisted men began to arrive from Fort Jackson to start their training. One of these trainees was the comedian Zero Mostel.

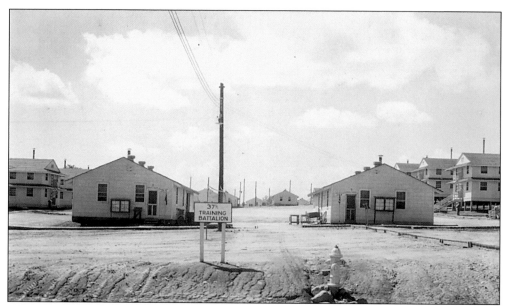

37th Infantry Training Battalion, Camp Croft. (Photoprint.) More than 200,000 troops passed through Camp Croft during the five years of its existence. Colonel Louis A Kunzig was the first camp commander. It was he who had suggested that the camp be named after Edward Croft. Kunzig was later succeeded by Brigadier General Oscar W. Griswold.

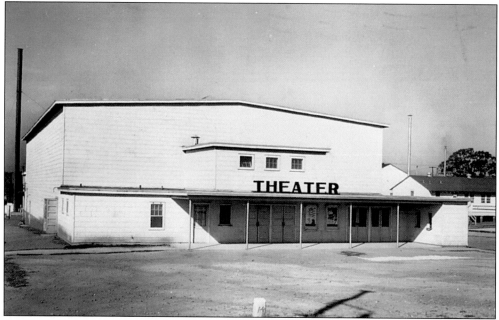

A Theater, Camp Croft. (Photoprint.) The camp had three theaters where offerings were changed three times a week, and admission charge was 14¢. One of these buildings would be used by the Spartanburg Little Theater after the war. The Little Theater's first professional director, David W. Reid, was stationed at Camp Croft.

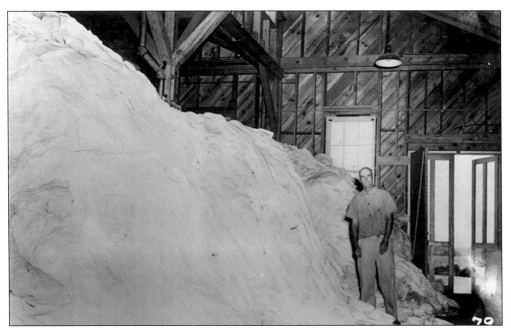

A Day's Washing at Camp Croft Laundry. (Photoprint.) With thousands of troops in training at Camp Croft, the mound of laundry is not surprising. (Card courtesy of Gayle and Danny Russell.)

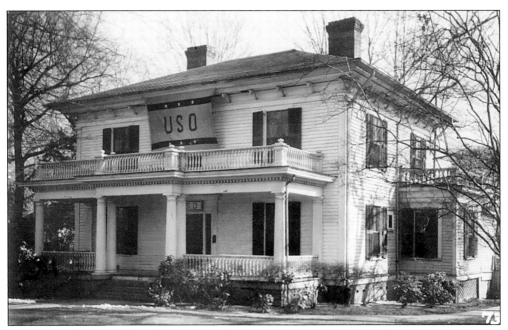

East Main Street USO. (Photoprint.) There were six United Service Organization centers in Spartanburg. They provided a place for the troops to relax and to meet young women from the community. This house on Main Street is no longer standing.

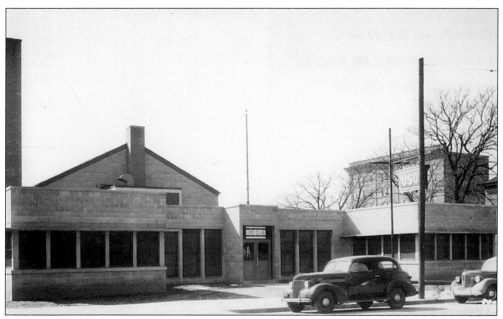

USO Club. (Photoprint.) One of the USO clubs in town was located on North Church Street. The Morgan Hotel, formerly the Gresham, is seen on the right in the background. Today, a law firm is located on this site.

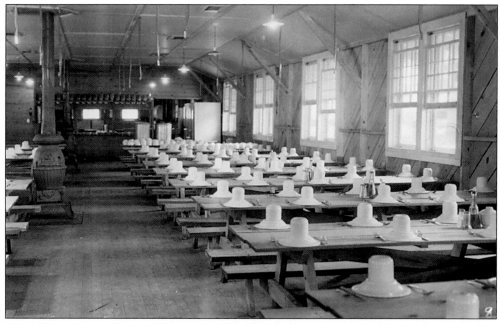

Mess Hall, Camp Croft. (Photoprint.) Bowls and plates are uniformly stacked at each place in the mess hall. After World War II ended, the Army decided to close Camp Croft. The land was sold to the Spartanburg County Foundation for redevelopment. Today, a state park occupies much of the area where men once trained for combat.